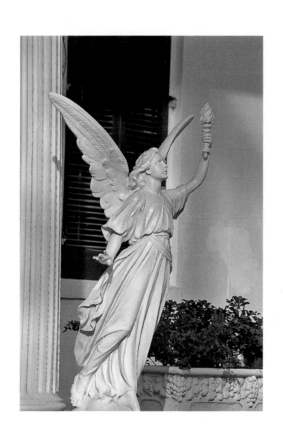

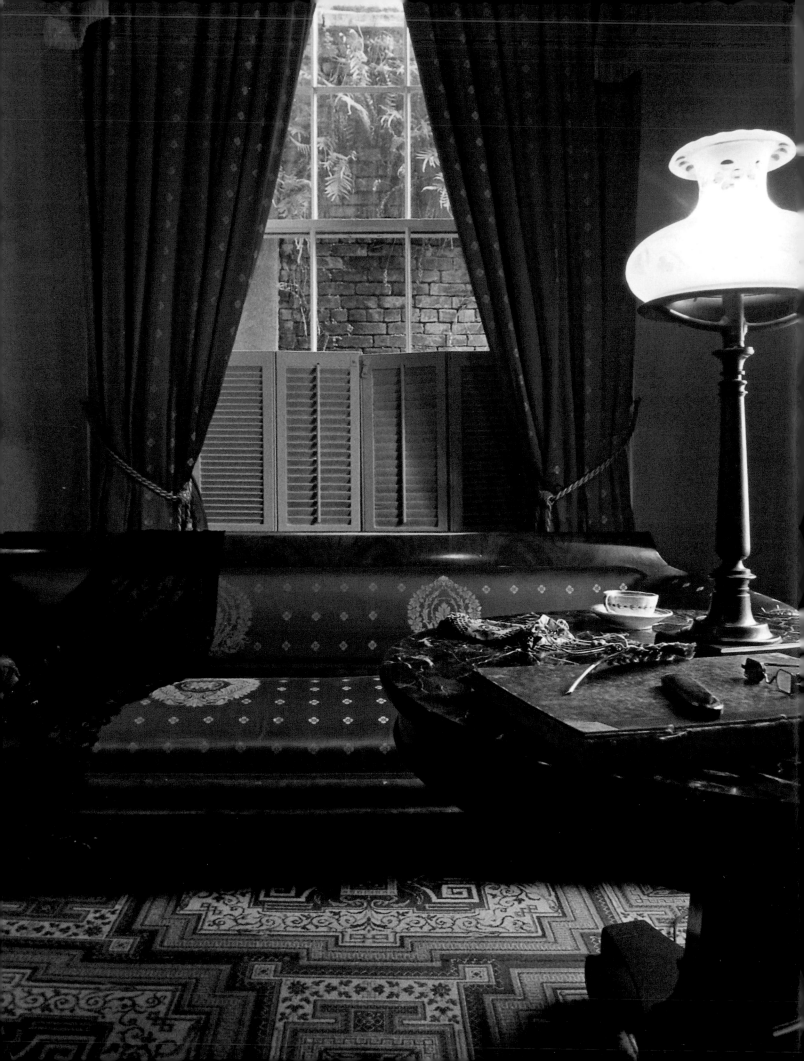

PLANTATIONS & HISTORIC HOMES OF NEW ORLEANS

Text by Jan Arrigo

Photography by Laura McElroy

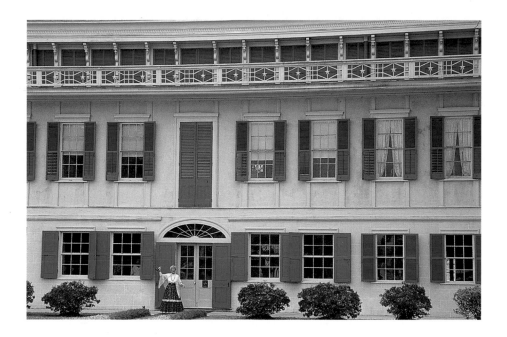

Voyageur Press

First published in 2008 by Voyageur Press, an imprint of MBI Publishing Company, 400 First Avenue North, Suite 300, Minneapolis, MN 55401

Voyageur Press titles are also available at discounts in bulk quantity for industrial or sales-promotional use. For details write to Special Sales Manager at MBI Publishing Company, 400 First Avenue North, Suite 300, Minneapolis, MN 55401

To find out more about our books, join us online at www.voyageurpress.com.

Library of Congress Cataloging-in-Publication Data

Arrigo, Jan, 1960–
 Plantations & historic homes of New Orleans/text by Jan Arrigo; photography by Laura McElroy.
 p. cm.
 ISBN-13: 978-0-7603-2974-0 (hardbound w/ jacket)
1. Historic buildings—Louisiana—New Orleans—Pictorial works. 2. Dwellings—Louisiana—New Orleans—Pictorial works. 3. Architecture, Domestic—Louisiana—New Orleans—Pictorial works. 4. Plantations—Louisiana—New Orleans—Pictorial works. 5. New Orleans (La.)—Buildings, structures, etc.—Pictorial works. I. McElroy, Laura A., 1951– II. Title. III. Title: Plantations & historic homes of New Orleans.

F379.N543A775 2008
976.3'35—dc22

Cover: "The Wedding Cake House," an 1896 Georgia Revival mansion, is one of the many homes worth seeing along New Orleans' St. Charles Avenue.

Frontis & table of contents: A closeup look at the intricate balcony and an angel statue at St. Elizabeth's, a onetime boarding school and orphanage built in 1865 in New Orleans' Garden District. This home is the former residence of author Anne Rice.

Title page, main: The front parlor room of the Hermann-Grima House depicts upper-class New Orleans life circa 1830 to 1860. The house was built in 1831 for German-Jewish immigrant Samuel Hermann. American architect William Brand designed this center-hall plan mansion. **Title page, inset:** A San Francisco plantation tour guide rings a bell, signaling the beginning of another tour of the home in New Orleans' River Road area. The plantation's attic has a unique Victorian construction with a hip roof pierced by tall dormers and arched Tudor windows.

Editor: Leah Noel
Designer: James Kegley

Printed in China

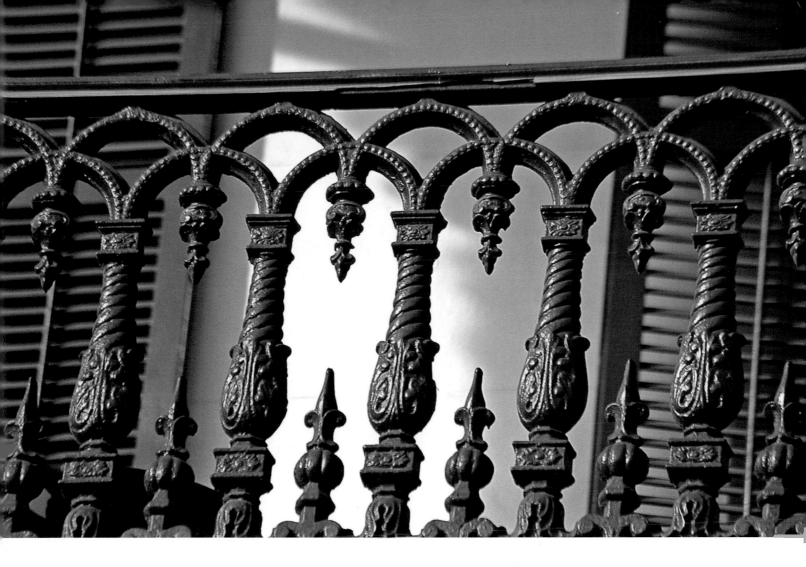

Contents

DEDICATION

To my husband Bryan, who showed me during the months after Katrina that it's possible to be happy even without a place called "home."

— Jan Arrigo

To my parents, Kathleen McElroy and the late Soule "Boots" McElroy, whose love and encouragement has been a beacon in my life.

—Laura McElroy

ACKNOWLEDGMENTS

Together we wish to thank the Louisiana State Museum, the Louisiana Landmarks Society, and the owners, administrators, curators, and guides connected with these properties: 1850 House, Beauregard-Keyes House, The Columns Hotel, The Cornstalk Hotel, Edgar Degas House, Destrehan Plantation, Faulkner House, Houmas House Plantation and Gardens, Gallier House Museum, Hermann-Grima House, Laura Plantation, Longue Vue House and Gardens, Madam John's Legacy, Oak Alley, Old Ursuline Convent, Pitot House, St. Joseph Plantation, San Francisco Plantation, and Woodland Plantation. Also thanks to Marion Chambon, Ott Howell, Lisa Samuels, Carolyn Bercier, Claire and Jacques Creppel, Foster Creppel, Mamie Sterkx Gasperecz, Bonnie Goldblum, David Villarubia, Joseph J. DeSalvo Jr., Rosemary James, Norman Marmillon, Josie Occhipinti, Mark Monte, Verna Monte, Sarita Varma, Susan Welber, Mary Kocy, Ruth Arrigo, and Melodie and the gang at Forest Sales and Distributing.

A FRENCH QUARTER COURTYARD. INTERIOR COURTYARDS FIRST APPEARED DURING THE CITY'S YEARS OF SPANISH RULE, WHICH BEGAN IN 1762.

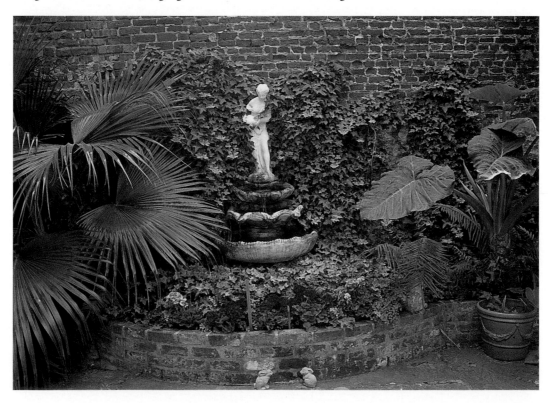

PREFACE: BUILDING HISTORY

Hurricane Katrina was an unprecedented reckoning—for New Orleans, Louisiana, and the Gulf Coast. After the shock of the floods, we mourned the people who perished, the neighborhoods ravaged, and the possessions lost. Now those of us living in the New Orleans area have had time to reflect on the importance of our architectural heritage and feel a curatorial responsibility as guardians and guides to our out-of-town friends and family who so often visit. After taking inventory of the oldest historic houses profiled here, it was a relief to find that all survived because they were mostly built on the higher ground of the original city.

I grew up alongside these old buildings, making frequent visits to the French Quarter from the lakefront. On Sundays, my family would often take a much-anticipated trek down Elysian Fields to the Quarter to get chocolate milk or *café au lait* and *beignets* (powdered donuts) at Café du Monde before mass at St. Louis Cathedral. After mass, we would take an afternoon stroll outside the iron gates of Jackson Square to admire and talk with the artists about their paintings on display. Much of this art then and now captures the ambiance of the historic homes and scenic hidden patios nearby.

Sometimes we would visit one of the numerous historic homes open for public tours. There we learned the house's story, perused the historic documents surrounding it, and saw its grand design elements and period furniture and paintings. At some point I started to reflect on the interconnections between the people long gone from these old houses and those with us here, now.

As in Europe and the oldest towns of the world, renovations are a constant must for upkeep, and the people responsible for them have become as important as the original builders. For example, I loved to hear my father-in-law's nostalgic stories about reroofing the Pontalba apartments in the 1960s, perched high above the Quarter. He described his private but temporary roof view of the river as heavenly. It takes skill and ingenuity to renovate these treasured buildings, and I realized how much pride people took in being a part of that, much like those profiled in *Raised to the Trade: Creole Building Arts of New Orleans*, a book and museum exhibition presented by the New Orleans Museum of Art in 2002.

When I was a teenager, I started visiting the nearby River Road plantations with my father, Joseph Arrigo, who was an artist devoted to capturing the exacting lines of these grand structures through stylized sketches. These family field trips fueled Cinderella fantasies of fireplaces in big bedrooms with high ceilings, canopied beds, ballrooms, and balconies set in wide-open spaces. My father was so enchanted by the antebellum homes that he was inspired to create no less than five books on the topic. These books gave new life to these homes by generating public interest in them.

Back home, my dad re-created those great buildings by dipping his pen in black ink on paper while the family had no choice but to watch him, since his glassed-in art studio was just behind the television. There, at a drafting table, he meticulously captured architectural elements through shading nuances and delicate lines. He romanticized them by often including natural details, such as curlicues of moss hanging from oak branches.

Another plantation introduction was through a high school friend. I got to know Mrs. Odessa Rushing Owen, a widow who lived at Nottoway Plantation longer than any other resident—from 1944 until her death at age ninety-five in 2003. She had negotiated to stay even after she sold the property in 1980, keeping busy with her charming shop on the grounds, which featured collectible dolls, crochet items, and local crafts. But when I first visited in 1979, Mrs. Owen's Nottoway was a marvelous disorder of papers, old photographs, antiques, and bric-a-brac. Until then, I had never seen a plantation that was actually lived in. Every room promised more intrigue, and so did Mrs. Owen. The former Louisiana State University professor was a captivating but reluctant storyteller, sharing real-life tales of living in a plantation with her husband Captain Stanford E. Owen, who lived here as a boy. She told of the time photographer Clarence

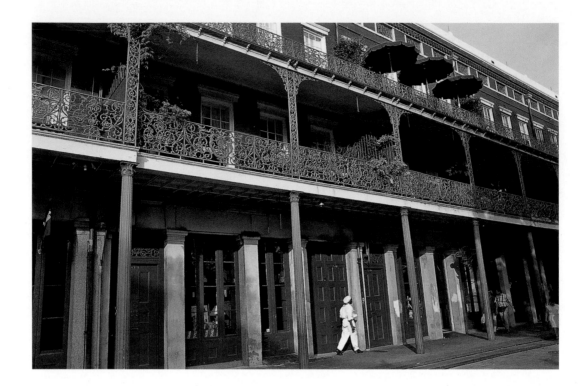

John Laughlin (1905–1985) stayed for three weeks as her guest when he was shooting for *Ghosts along the Mississippi*, a landmark book that profiled the deteriorating antebellum homes. But Mrs. Owen was dismayed that Laughlin only photographed her laundry hanging on the clothesline and nothing else of the grand home. Today, overnight guests of the plantation can stay in her old bedroom. Odessa's Room still features her mahogany, half-tester double bed with a new addition: a Jacuzzi in the private bath.

My next encounter with the historic buildings and properties in New Orleans came in the 1980s during my first job out of college. I worked for Helen R. Dietrich's destination tour company, the first of its kind in New Orleans. The company (which still exists as Dietrich Destination Consultants, Inc.) devised entertainment and tours for associations meeting in New Orleans. Many of the stops on the tours were at the city's finest historical properties and nearby plantations. As a rep for the firm, I had to go on the tours and write about them, which was of course the best part of the job. The guides' narratives were great, and I especially enjoyed their droll and witty comments about house decor and furnishings. These ladies and gentlemen knew their stuff. And so did Mrs. Dietrich, an enterprising, stylish, older businesswoman whose favorite word was "nifty." She had been a court reporter in the 1960s and was the transcriber in the state's case against Clay L. Shaw (who was accused of conspiring with Lee Harvey Oswald), the only trial involving the assassination of John F. Kennedy.

Last, when writing about New Orleans for the first book that photographer Laura McElroy and I conceived (*New Orleans*), I made it a point not to include "The City that Care Forgot" as one of the town's nicknames. I did not want to perpetuate the sentiment. I cared about my hometown and felt a longing to return. I had been writing from New York City where I'd relocated in the 1980s, but after 9/11 I just wanted to come home.

When I did, my endless fascination with New Orleans and the lives lived here—past and present—did not wane. A book on the city's cemeteries followed, and when I researched the names on headstones of the above-ground tombs and traced them to their civic deeds and often lavish homes, I only became more

curious about the people who had helped shape the city with such distinctive dwellings. The historic houses are witnesses to the personalities who built and occupied them. This book tells the stories of these people and covers dwellings built primarily in the 1800s, but also those that date between 1752 and 1945. All survived Katrina, and most are open to the public as historic-house museums or hotels. Plantations and houses listed in the third section of this book also include many private homes with distinctive architecture and history.

Of course, many homes built outside the highest ground of the original city were destroyed after the levees broke and Katrina's floodwaters overtook them. The remaining structures will survive because of our attention. We are the caretakers, supporting these great homes in spirit and action. Happily, New Orleans is still a treasure trove of vernacular architecture. The city and surrounding area's collection of building styles is culturally diverse—as are the architects, builders, craftsmen, draftsmen, engineers, laborers, occupants, owners, restoration nonprofits, and work crews who created and restored them. And for those who visit New Orleans, it's hard to imagine this city without its setting of architecturally distinct houses and buildings, which provides a beautiful backdrop for strolling around to see, smell, and taste what is most assuredly nothing like what is back home.

A WINDOW IN THE RESTAURANT OF NOTTOWAY OVERLOOKS THE COURTYARD FOUNTAIN. NOTTAWAY PLANTATION WAS COMPLETED IN 1859.

INTRODUCTION

Early French towns in the United States usually had a common planning pattern: a narrow linear grid on a river with a *place d'armes*, or military fort, near the water's edge for protection. By 1723, the city of New

BELOW: TWO FRENCH QUARTER SHOTGUN HOUSES ARE SHOWN HERE. THIS TYPE OF HOME WAS BUILT FROM 1840 UNTIL THE 1920S AND WAS AN AFFORDABLE OPTION FOR WORKING-CLASS FAMILIES.

Orleans fit this pattern, but when it was first visited by French-Canadian explorers in 1682, the future site of Mardi Gras was nothing more than a canebrake on a crescent of the Mississippi River. Living nearby were Indians from the Choctaw, Creek, Chickasaw, Caddo, Shawnee, Arkansas, Apache, and Osage tribes—none of which posed a threat because, until 1727, the policy was to allow Native Americans to maintain ownership of their tribal lands.

Early residents constructed their homes and businesses from what was available in nature. Structural styles evolved from elements borrowed from the countries of origin of New Orleans' newest arrivals. Each architect, engineer, and construction worker brought with him an innovation or improvement. Dating from 1762 to the 1850s, these hybrid structures have come to be called Creole, after the term's original meaning for a native-born New Orleanian of French or Spanish descent. In the book *Raised to the Trade: Creole Building Arts of New Orleans*, the author of the "Vernacular Vision" chapter, Jay D. Edwards, asserts that the Creole layered artistry is hidden and complex:

> Underlying the artistry of the plaster cornice, the brick entablature, the delicate wrought iron *garde-de-frise*, the turned cigar-shaped Creole colonette, the Federal overmantle, or the Eastlake piercework and spindle frieze, lie the strength of the brick chain wall, the adaptive elegance of the broad living gallery, the intricate logic of the "Norman" truss, the geometric aesthetic of the hall-less "Spanish" West Indian Creole floor plan, the rhythmitized motor skills of the lather, and the mechanical efficiency of the *bousillage* timber framed wall. Not only is much of this hidden from sight, even that which is in plain sight is largely hidden from comprehension.

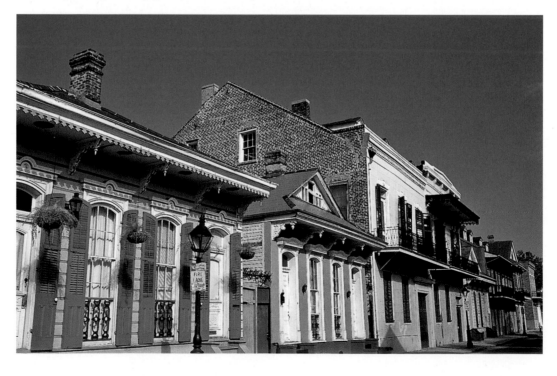

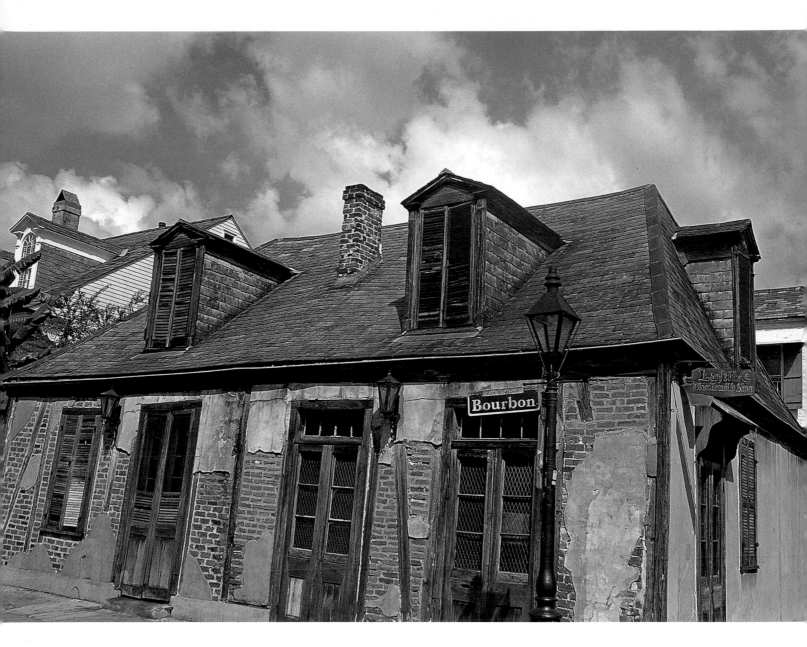

The longest lasting designs, the ones that survive, do so because of their compatibilities with culture, geography, and nature. If what's left is aesthetically pleasing, we can thank the African, Caribbean, and Creole architects and builders in the same vein as the original European and Greek architects for their style and influence.

DATING FROM THE 1780S, THE BUILDING KNOWN AS LAFITTE'S BLACKSMITH SHOP—LOCATED AT THE CORNER OF BOURBON AND ST. PETER STREETS—IS AN EXAMPLE OF FRENCH COLONIAL ARCHITECTURE.

Establishing the City

The first of the New Orleans' French-speaking settlers was Robert Cavelier, Sieur de La Salle, a French Canadian who discovered the Gulf of Mexico and claimed the lands adjacent to the Mississippi River as *Louisiane* to honor then-king-of-France Louis XIV. Then in 1699, Pierre Le Moyne, Sieur d'Iberville, established Louisiana as a French colony. After New Orleans was formally incorporated in 1718, eighty men

convicted of stealing salt, who had been doing time in France, became its first full-time inhabitants. Other convicts and undesirables followed.

The main reason people were interested in the city named Nouvelle Orleans (after Phillippe, Duc d'Orleans, a regent of France) was that an elaborate colonization scheme had been cooked up by a Scotsman whose name was, ironically, Law. He had folks in France believing that the bug-infested swamp on the coast of the Mississippi was the new Eden, so they invested in it. When the bubble burst, the scheme came to be known as Law's Mississippi Bubble. Yet if it had not been for Law's advertising lies and France's *les misérables* who were forced to move here, the indigenous tribes might have held on to the crescent-shaped land on the river for a while longer.

In 1721, military engineer Adrien de Pauger laid out New Orleans with sixty-six uniform squares fronting the river with a *place d'armes*. Overlooking this square was a barracks, a church, a prison, and a rectory. This layout remains today, but a statue of Andrew Jackson now stands near the site of the gallows, and the prison behind the Cabildo has long been relocated.

Just one year after the city was laid out, a devastating fire broke out, and two thirds of the houses in the area were destroyed. These were the city's first wooden structures made of readily available, rot-proof cypress.

An Enduring French Colonial Legacy: The Ursulines and Their Convent

The Old Ursuline Convent, a plantation in the French Colonial style of 1745 to 1750, is an intact survivor from this time and is considered a formative architectural trend. Its building was authorized by King Louis XV of France. Key elements of this style include a steep roof spread over a truss, casement windows and doors, and batten shutters, with balconies or galleries as a major innovation thought to be borrowed from the Caribbean. There was no separation of church and state during both French and Spanish rule before the Louisiana Purchase, and these nuns, their plantation, and social services were invaluable in the city's formation. The plantation convent building was also important to the history of the city because it served as a hospital for wounded soldiers during the Battle of New Orleans.

"Country": The Cajuns and Germans Settle Upriver

New Orleans' farms and plantations came as the result of French land grants, which were measured in *arpents*, just as they were in northern France (an arpent is a French measurement of approximately 192 feet, and a square arpent is about 0.84 acres). Grants of long and narrow parcels of land (often 2 to 4 arpents wide by 40 to 60 arpents deep) along major waterways and bayous were selected as the most suitable for cultivation and habitation.

These grants allowed transplanted Germans from the Rhine area (fleeing the effects of the Thirty Years War) to settle there. The farmers settled along the Mississippi River in an area called *La Côte des Allemands* (the German Coast) and grew vegetables destined for tables in town and country.

A large population of Cajuns (Acadians—from Acadia, now Nova Scotia), who had refused to pledge allegiance to the British Crown and give up their Catholic religion, arrived in the United States en masse in 1785. More than one thousand came to south Louisiana rather than Protestant America because French was spoken here, and they could attend mass in peace. They, too, farmed the land. Their crops included indigo,

rice, and tobacco before sugarcane dominated. Cotton, cultivated in the northern part of the state, was in the ensuing years processed and shipped worldwide from the port of New Orleans via the Mississippi River.

Plantations, or large farm estates, became prevalent in this area by the early 1800s. The private mansions doubled as administrative offices, where important business and entertaining took place. Both the country and the town needed each other for survival. Food grown from the country was sold at the roofed strip market extending from St. Ann Street to Rue de l'Arsenal (now Ursuline). Now known as the French Market, this was originally a Choctaw Indian trading post, where these indigenous peoples from north of Lake Pontchartrain sold crafts, herbs, and spices. The market that remains today was built in 1813, but it has undergone numerous renovations.

BELOW: THE WALL ON THE LEFT IN THIS PHOTOGRAPH SURROUNDS THE OLD URSULINE CONVENT, AN INTACT SURVIVOR OF NEW ORLEANS' FRENCH COLONIAL PERIOD.

Because of geography, waterways, not roadways, usually transported goods and people. For simple trips, a dugout canoe called a *pirogue* was used, and *bateaux flats* (flatboats) carried hides, furs, and wools upriver and beyond. Bayous, lakes, and, of course, the Mississippi River made the trip between the two possible, and people would visit for days. Most wealthy landowners had both a town and a country home and would travel these waterways as the most direct route between them. This transportation was much faster than using horse-drawn carriages on muddy roads. The 1820s saw the arrival of the steamboat era in New Orleans, as the vessels transported goods and folks en masse to the towns along the Mississippi River. Many boats resembled floating hotels, with restaurants serving dishes on fine china and wines in crystal. These were the cruise ships of their day, and gambling was a favorite activity aboard.

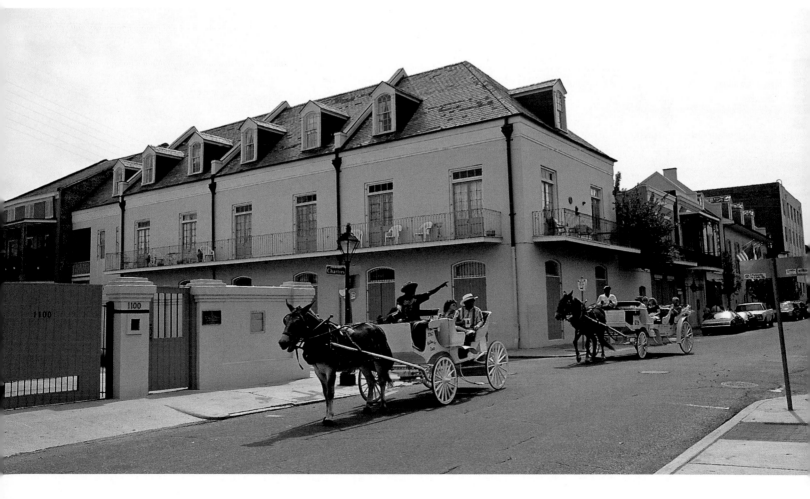

The Good Friday that Wasn't

On Good Friday, 1788, a devastating fire destroyed most of New Orleans. Still a fort with cannons at each corner of the grid, the city of more than 5,000 was full of structures with wooden, shingled roofs and walls constructed in the French *briquette-entre-poteaux* (brick-between-post) style, requiring the protection of stucco or weatherboards. The fire destroyed all but 150 of these. Two of the survivors were the Old Ursuline Convent and the house known now as Madame John's Legacy, which still stands at 632 Dumaine.

The fire started in the private chapel of Don Vicente Jose Nunez, the military treasurer and a devout Catholic, who had lit more than fifty candles on that Good Friday. The blaze started accidentally when his curtains caught on fire. *The London Chronicle* carried the story on August 19, 1788, describing Nunez as "a zealous Catholic" because of the number of candles he lit that March Friday, but added that New Orleans was at that time " . . . the most regular, well-governed, small city in the western world."

OPPOSITE: THIS GARDEN DISTRICT HOME DISPLAYS A CAST-IRON BALCONY. THE GARDEN DISTRICT WAS ORIGINALLY PART OF LIVAUDAIS PLANTATION AND WAS FIRST DIVIDED INTO PLOTS IN 1825. IT IS A LARGE SQUARE AREA BOUNDED BY JACKSON AVENUE, LOUISIANA AVENUE, MAGAZINE STREET, AND ST. CHARLES AVENUE.

Hola! Spanish Rule

Out of the ash came buildings incorporating a Spanish style, many with hidden courtyards in the middle. Other key elements of this style include wrought-iron or hand-forged iron balconies (galleries), louvered shutters, plastered interiors, stucco exteriors, arched entryways, carriageways, and separate-wing service rooms. While Spanish architectural influences prevailed after the change to Spanish rule in 1762, French language and culture continued.

Another great fire in 1794 consumed about two hundred wooden homes. After this blaze, the Spanish government created bucket brigades, new building codes, and laws that required all common walls to be made of brick and to extend higher than the roofs of both buildings, so that there was a fire wall.

The Expanding City

Architect and Freemason Benjamin Henry Boneval Latrobe, creator of Philadelphia's first waterworks and the U.S. Capitol building in Washington, D.C., came to New Orleans in 1819 to work on a project for the waterways. In *Impressions Respecting New Orleans: 1818–1820*, the man now considered to be the father of architectural study in the United States described the city that was expanding geographically:

> New Orleans, beyond Royal Street, towards the swamp retains its old character without variation. The houses are, with hardly a dozen exceptions among many hundred, one-story housed. The roofs are high, covered with tiles or shingles, and project five feet over the footway, which is also five feet wide. The eaves therefore discharge the water into the gutters. The highth [sic] of the stories is hardly ten feet, the elevation above the pavement not more than a foot and a half; and therefore the eaves are not often more than eight feet from the ground. However different this mode is from the American manner of building, it has very great advantages both with regard to the interior of the dwelling and to the street. In the summer, the walls are perfectly shaded from the sun and the house kept cool, while the passengers are also shaded from the sun and protected from the rain.

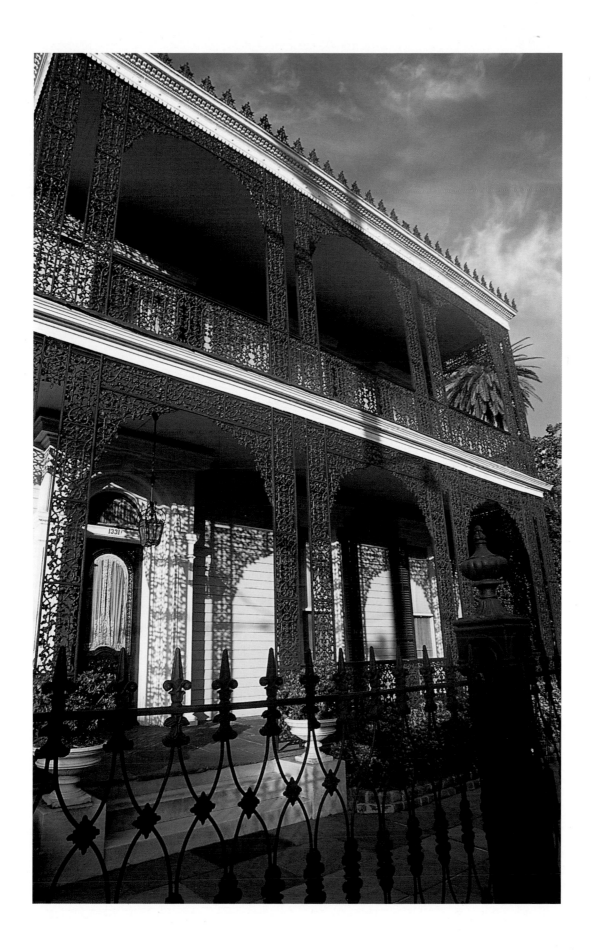

Latrobe's observations came from walking past the original city of what is now called the French Quarter into the adjacent *faubourg* (neighborhood) known as Marigny. This area had been a plantation owned by Bernard de Marigny (who had squandered the spread by gambling). Latrobe was comparing these houses with those deriving from the British, such as those built in the original thirteen colonies. For example, elements of urban houses in Baltimore and Philadelphia included a public passage with stairs acting as a common sewer without the means to preserve a comfortable interior temperature. Latrobe was noting that these colonial homes were literally not cool.

What's Very Old Is New: The Classic Revival

After the American Revolution, architects like Benjamin Latrobe, who was from England, looked to classical architecture from Greece and Italy, where the majestic, harmonized proportions matched the political aspirations of the young republic. The national buildings and monuments built in Washington, D.C., were just a start. Those who could afford it wanted an architect versed in Federal and Greek Revival styles for their homes. The Federal style placed emphasis on the central entrance, with stylistic characteristics including a low-pitched or flat roof likely concealed behind a balustrade with low relief moldings and plain façades (especially common in Puritan New England).

In 1826, innovative architect François Correjolles incorporated Federal-style elements—including a fan light or transom over doors, classical detailing of the entryway, Palladian and double-hung sash windows—in the Beauregard-Keyes House on Chartres Street (built for auctioneer Joseph Le Carpentier).

By 1857, the Greek Revival style was nearing its peak when architect James Gallier Jr. built his stunning Greek Revival home, now known as Gallier House, with the grandest, most desired luxury of the day: an indoor toilet. Greek Revival was the continuation of the neoclassical, ushering in stylistic elements that conjure every pillared plantation in the South: a pediment gable, symmetrical galleries and wings, a heavy cornice, and a plain, wide frieze with simple moldings. Basically, it's the Greek temple transformed into a dwelling through pattern books or catalogues and illustrations.

Approximately six years earlier, Gallier had drawn up plans for an unusual double row of townhouses that were also to have their own bathrooms. Although the Baroness Pontalba fired him, using Henry Howard instead, the Pontalba buildings perpendicular to the river were finished in 1850 using sketches that resembled the Place des Vosges on Paris' Left Bank. The baroness is also responsible for transforming the park that lies between the Upper and Lower Pontalbas and extends from the Place d' Armes to Jackson Square, which was dedicated with a gleaming new sculpture of Andrew Jackson on his horse. In fact, the general is supposedly saluting the baroness' balcony. The 1850 House is the historic townhouse museum within the restored building.

Gone with the War

In January 1861, Louisiana seceded from the Union following the presidential election of Abraham Lincoln, who threatened the state's agricultural economy by wanting to abolish slavery. By then, New Orleans was the largest city in the South with more than 100,000 people, according to the 1860 census. The port was bustling with commercial enterprise, since more than half of the nation's cotton exports passed through here along with sugar and tobacco. Just one year after joining the Confederacy, New Orleans was captured by the Union without a battle in the city itself, though skirmishes occurred at downriver forts

Jackson and St. Phillip before they surrendered. That left New Orleans intact with a large inventory of historic buildings and homes that have survived to this day.

In the country, many plantation buildings survived and others were left to crumble. Nottoway was spared from ruin after being spotted by a sentimental Northern gunboat officer who had once enjoyed himself at a gracious ball there. He demanded a cease-fire, thus saving the grand old home.

Yet after the war, the mighty Mississippi River could no longer compete with a burgeoning railroad system, which proved cheaper, faster, and, with no pirates or storms to contend with, safer. Of course, with the end of slavery, the economics of life on the River Road plantations were never the same. For the freed slaves came the harsh reality of becoming indentured servants, working for their masters for meager wages, or starving. Others moved to town, a place transformed by a new set of rules.

A Building Renaissance

Following the Louisiana Purchase in 1803, the new American immigrants began to settle beyond Canal Street just above the French Quarter. They resided on Lafayette Square (now the Central Business District) first and then spread out to the Garden District.

After the war was a harsh Reconstruction. Wealthy carpetbaggers and the new Americans poured into town with money for construction. In the 1880s, New Orleans, specifically St. Charles Avenue, was in the midst of a building renaissance. Uptown, as it is known today, came into prominence following the cotton exposition that was held on part of the Livaudais Plantation (Audubon Park today). The post–Greek Revival vogue was to build homes exhibiting eclectic Victorian architecture inspired by villas constructed during the Italian Renaissance. A wonderful example of an Italianate design is Thomas Sully's residence for tobacco millionaire Simon Hernsheim. It features massive columns, which is the reason the home is now called the Columns Hotel. Italianate-style homes often feature an asymmetrical floor plan, bay windows, segmented arch openings, keystones, bracketed cornices, and profuse decorative details, such as acanthus leaf and scroll carvings in relief. Other characteristics borrowed from the Italian Renaissance include eaves supported by corbels, low-pitched roofs, and towers approximating Italian belvederes or campaniles. Columns or paneled pillars are common elements of this style, too.

Over the next century, home styles evolved to include the raised shotgun, the raised basement bungalow–style home, and the modern ranch built on a slab in the only place left to expand the city limits: the low-lying swamp. When A. Baldwin Wood designed a heavy-duty pump that could handle large volumes of water and debris in the 1920s, New Orleans planners used these pumps to drain Mid-City and the lakefront, making way for the precarious suburbs whose soggy fate played out when the levees broke after Katrina.

Although these areas have been through the ringer with floodwaters and further damage by vandals, many New Orleanians are undaunted by the catastrophe that was the worst natural disaster in U.S. history. They have returned to gut their homes and start anew while monitoring the levee construction.

And so New Orleans still has its charm—from the original city in the French Quarter with Creole houses featuring courtyards and iron "lace" balconies, out to the Esplanade Ridge and Uptown's Greek Revival and Italianate Victorians above Canal Street. In the country, surviving Creole and Greek Revival plantations surrounded by oak-covered grounds near the river await a new generation of owners, renovators, and visitors. The most renowned of these are featured within these pages and are usually open for public viewing. Welcome!

Working-Class Models:
The Creole Cottage and Shotgun

The Creole cottage first started appearing in New Orleans around 1790 and resembled a Caribbean cottage. The floor plan included a wide center hallway, flanked by side parlor rooms, that led to a gallery in the rear. The homes were two rooms wide and two rooms deep with French doors connecting the principal rooms. In the rear were two small rooms called cabinets, and between them was the loggia.

The Creole cottage's exterior featured two windows and French doors. The double parlors often were used as commercial space, for this building was primarily an urban structure. The roofs were steeply pitched, with a front overhang and many with dormers. Given the street orientation, the back rooms were reserved for quiet privacy. Street noise and sunlight could be blocked out by closing the casement window shutters, which also offered protection from tropical weather. The style's popularity ended around 1850.

Creole cottages, and later shotguns, were the homes built for working-class Creoles, immigrants, and free people of color because they were inexpensive. They were built closely together and right up to the edge of the street. The cottages were parallel to the curb, while the shotgun styles were perpendicular to the street so many could be squeezed into a single block.

Shotguns first appeared in the 1840s and were popular until the 1920s. They got their name because if you shot inside the house the bullets could easily travel through the long length of the house, from front to back. Long and narrow, shotgun homes had three or four rooms stacked one behind the other, with no hallway, under a continuous gable roof. Double shotguns were designed as two-family homes of the same floor plan that shared a wall. A camelback shotgun was a modified version, which had a second story above the back rooms. Shotguns are thought to be possible evolutions of ancient African long houses.

Both Creole cottages and shotguns featured strategically placed windows and doors to allow for cross ventilation. Following Hurricane Katrina, prefabricated house manufacturers touted their raised "Katrina Cottage" designs, which mimic the shotgun as common-sense models, given the geographic location.

New Orleans and Mississippi Delta Map

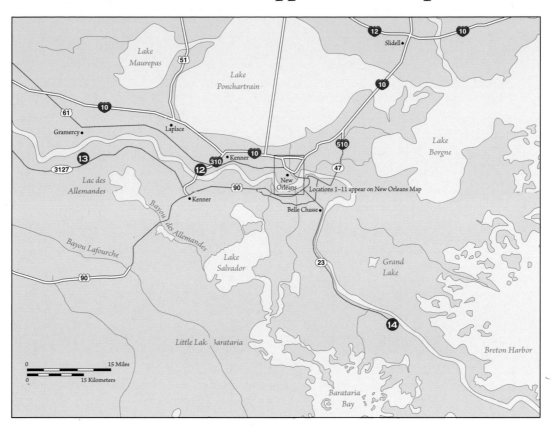

New Orleans City Map

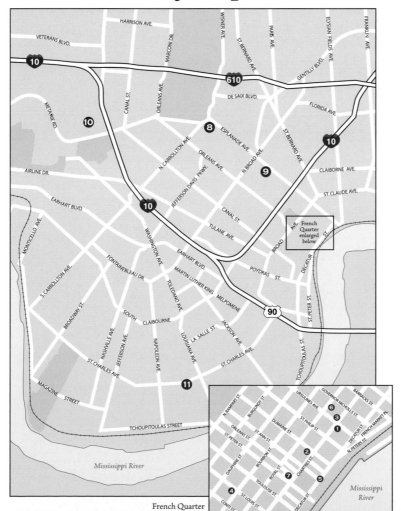

1. OLD URSULINE CONVENT
2. MADAME JOHN'S LEGACY
3. BEAUREGARD-KEYES HOUSE
4. HERMANN-GRIMA HOUSE
5. 1850 HOUSE, LOWER PONTALBAS
6. GALLIER HOUSE
7. FAULKNER HOUSE
8. PITOT HOUSE
9. EDGAR DEGAS HOUSE
10. LONGUE VUE HOUSE AND GARDENS
11. SIMON HERNSHEIM HOUSE/THE COLUMNS HOTEL
12. DESTREHAN PLANTATION
13. LAURA PLANTATION
14. WOODLAND PLANTATION

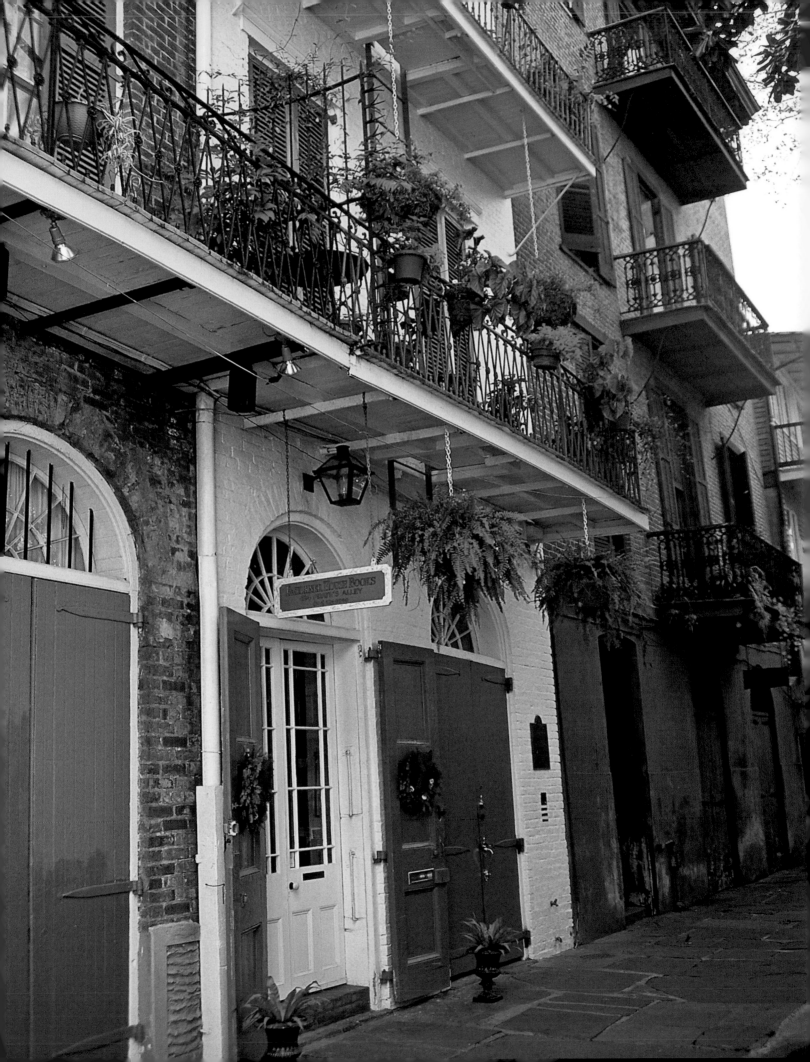

THE FRENCH QUARTER

The modern-day French Quarter encompasses sixty-six blocks of the original colony of New Orleans, which was enclosed by ramparts in 1718. Decidedly Spanish in flavor, the structures are deep and narrow with rear courtyards. Most buildings are a mix of commercial and residential, with shops on the first floor facing the street and residences above and in the rear.

By the late 1900s, the area was in decline, and immigrants from Ireland and Italy moved into the then-decaying structures. The low rents of the 1920s attracted a bohemian following, and their literary presence attracted attention that led to historic preservation by 1936. An ill-fated 1965 proposal to place the federal interstate highway here was halted by the newly formed historic district commission.

Today, this commission continues to review every alteration to any building in order to keep the area's historic appearance. The group has imposed height restrictions on new construction and a moratorium on new hotels. Amid the hustle and bustle of tourists who frequent the area, the French Quarter is still very much a real neighborhood, where people live, work, and shop.

ABOVE: THIS VIEW OF THE UPPER PONTALBA BUILDING SHOWCASES ITS ELABORATE, FRENCH ORNAMENTAL CAST-IRON BALCONY WITH SCRIPTED "AP" (FOR ALMONASTER AND PONTALBA) MONOGRAM. FACING PAGE: PIRATE'S ALLEY IN NEW ORLEANS' FRENCH QUARTER IS ONE OF THE CITY'S MUST-SEE LOCATIONS. THE ALLEY IS ONE BLOCK LONG, EXTENDING FROM CHARTRES STREET AT JACKSON SQUARE TO ROYAL STREET. THE ORIGINAL 1840 WROUGHT-IRON BALCONIES REMAIN AT THE FAULKNER HOUSE, WHICH IS NEAR ROYAL STREET IN PIRATE'S ALLEY. THE ARCHED GROUND FLOOR OPENINGS OF THE HOME WERE DESIGNED FOR COMMERCIAL TENANTS AND WERE A SPANISH ARCHITECTURAL CONTRIBUTION.

Old Ursuline Convent

By the middle of the eighteenth century, [the Ursuline nuns] were the mistresses of two plantations and a part of the circle of major slaveholders. Although their plantations and bond people proved to be the foundation of their New World wealth, they were not the sustaining element of the convent economy. As the century drew to a close, the nuns' primary source of income was the money paid to them for services they provided. They received stipends from the Spanish crown for operating a hospital, sheltering orphans, and providing public education to girls in a day school.

—Emily Clark, *Masterless Mistresses: The New Orleans Ursulines and the Development of a New World Society 1727–1834*

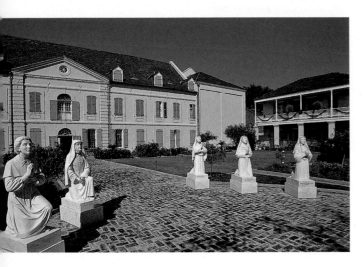

ABOVE: THIS STRUCTURE BUILT FOR THE NUNS WAS THE SECOND ONE ERECTED FOR THEM. IT WAS BUILT IN 1745 BY IGNACE FRANÇES BROUTIN.

FACING PAGE: THIS LONG, TRIMMED HEDGE LEADS TO ONE OF THE OLDEST INTACT BUILDINGS IN THE MISSISSIPPI RIVER VALLEY, THE OLD URSULINE CONVENT. THE FORMAL GARDENS SURROUNDING THE CONVENT WERE RE-CREATED BY EDWARD WOOLBRIGHT IN 1941.

New Orleans history would not be the same were it not for the Ursuline nuns. Originally requested by City Commissioner Jacques Delachaise to serve as nurses and trained pharmacists, the nuns from the French Company of Saint Ursula in Roen, France, really made their mark on the city by educating women and girls of color and European descent who integrated with Indians and West African slaves. By providing this crucial service work, they changed the demographics of New Orleans to include a non-Caucasian, Catholic majority.

The mission of the "gray sisters" expanded only two years after their arrival. When Natchez Indians attacked a French colony settlement at Fort Rosalie in 1729, the nuns took in girls who were orphaned in the incident. In later years, the Ursuline sisters established a school for underprivileged girls and a hospital, while continuing to operate their orphanage. They also became known for making highly valued point lace, petit point tapestries, and cork lace, as well as simple, tropical-themed quilting designs of palm, oak, and banana.

The Old Ursuline Convent at 1100 Chartres Street is a surviving example of the French Colonial (1718–1763) period in the Mississippi River Valley, but it was not the first building the Ursuline nuns lived in. They first resided in Widow Kolly's house, which became the first charity hospital. Their second home was this 1745 structure, a French Colonial plantation-style with a steep, hipped roof and casement windows and doors. At one time, the convent also had a long plantation-style gallery at the rear of the convent (which faced the Mississippi River). It also featured a large rooftop clock that faced back to the town. What remains of this original structure is the principal "floating" staircase. Its stylish design of curved wood and a banister worn smooth by use is a highlight of any tour to the convent, which is now a museum and archive for the Archdiocese of New Orleans.

In 1845, St. Mary's Church was constructed on the grounds and adjoins the convent building with a side entrance. The church reached its zenith in terms of

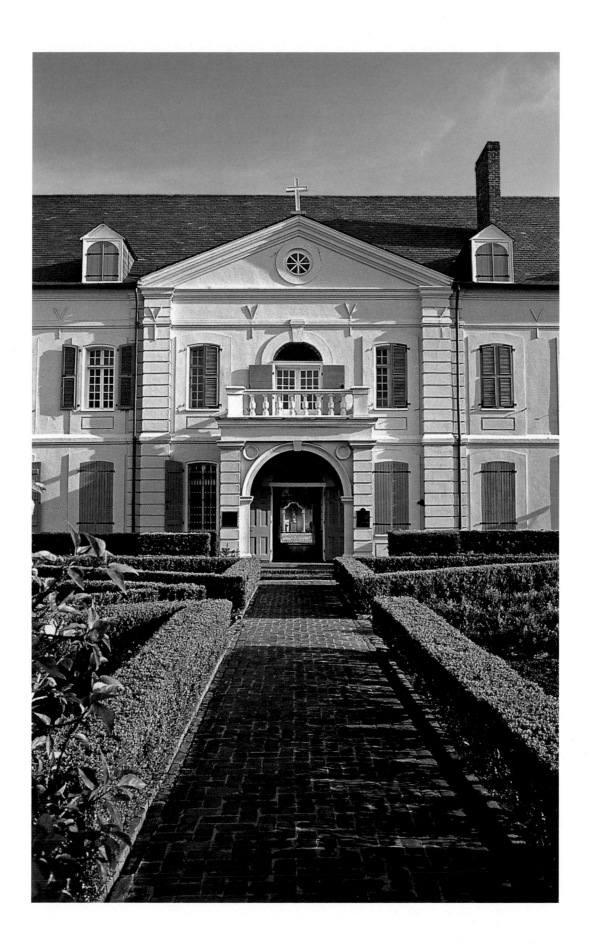

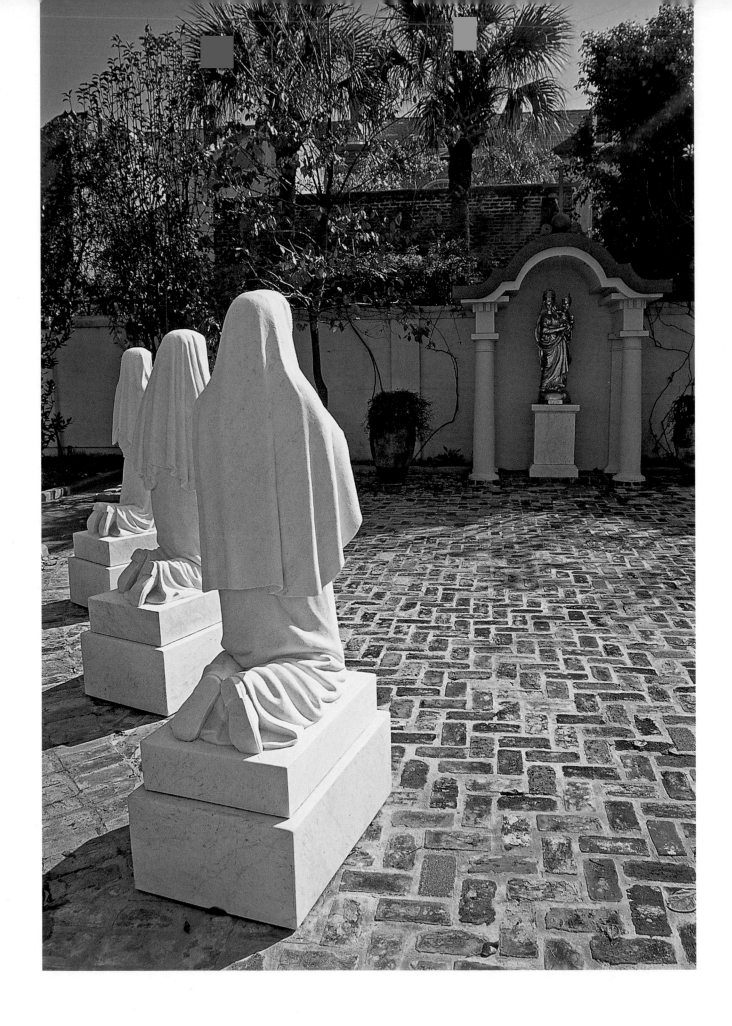

attendance when Italian immigrants lived in the French Quarter in the 1920s. One of the church's stained-glass windows reveals the interior library of the original archbishop of New Orleans. Following Hurricane Betsy in 1965, the convent's ceiling dropped and was removed, revealing an original ceiling that has now been restored.

The church, convent, and grounds originally covered several city blocks. The grounds are still home to a beautiful parterre herb garden within the brick-walled courtyard. Convent guides tell visitors that Sister Frances Xavier was the first female pharmacist to use herbs, such as oregano and bay leaves, from this garden to treat rheumatism and sprains, respectively.

While the convent replaced earlier structures on this property, it is still called the Old Ursuline Convent because the contemporary convent and school is uptown on Nashville Street.

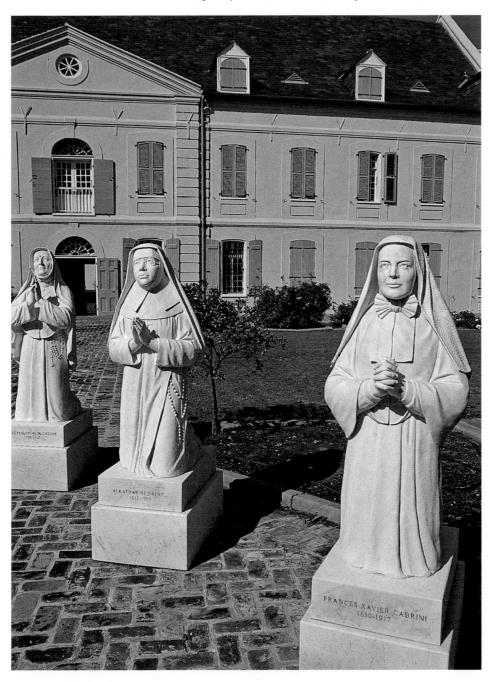

FROM 1973 TO 1978, THE ARCHDIOCESE OF NEW ORLEANS RESTORED THE OLD URSULINE CONVENT, ADDING THESE SCULPTURES TO THE COURTYARD. THE CONVENT WAS ESTABLISHED IN 1727 AND WAS INSTRUMENTAL IN THE CITY'S FORMATION.

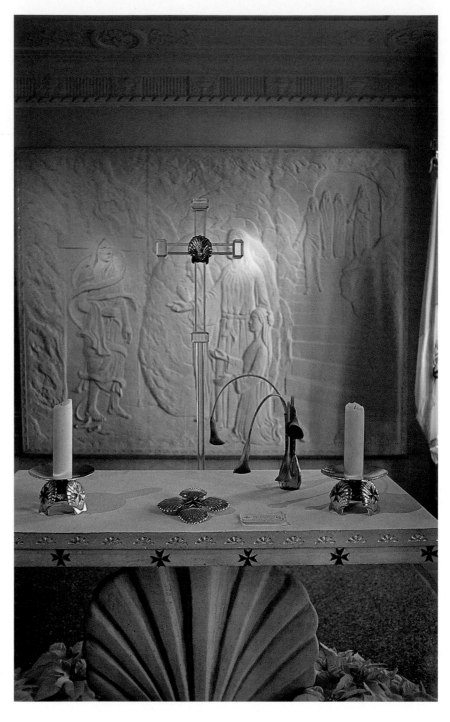

TOP LEFT: ST. MARY'S CHURCH, ADJACENT TO THE URSULINE CONVENT, IS NOW MAINTAINED AS A SACRED HISTORICAL EDIFICE, AFFORDING LIMITED RELIGIOUS SERVICES FOR NEIGHBORS AND VISITORS. ITS ORIGINAL NAME WAS SAINTE MARIE DE ARCHEVECHE. **TOP RIGHT:** ST. MARY'S HAS SERVED SUCCESSIVELY AS A PLACE OF WORSHIP FOR THE FRENCH, SPANISH, CREOLE, IRISH, GERMAN, SLOVENIAN, AND ITALIANS WHO HAVE MADE NEW ORLEANS HOME. **FACING PAGE:** ST. MARY'S CHURCH WAS BUILT IN 1845 AS THE CHAPEL OF THE ARCHBISHOPS. THE ADJACENT CONVENT BECAME THE ARCHBISHOP'S RESIDENCE IN 1824, WHEN THE NUNS VACATED TO ANOTHER CONVENT DOWNRIVER.

Madame John's Legacy

If any gentleman should ever love you and ask you to marry, not knowing . . . promise me you will not tell him you are not white.

—'*Tite Poulette*

This French West Indies Colonial cottage is known as Madame John's Legacy because it is mentioned as the setting in '*Tite Poulette*, a short story written by George Washington Cable in 1879. The story focuses on Zalli, a quadroon (of mixed race) mistress of a white man, who raises their beautiful daughter, 'Tite Poulette (French for little chicken), in a Dumaine Street house. Because

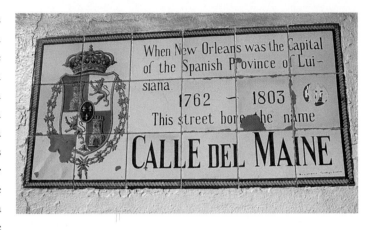

Zalli's lover is named John, she is also known as Madame John. The story of her legacy is that of urging her daughter (who looks white) to forgo her own fate of becoming another white man's mistress, as she did in following the tradition known as *plaçage*. This tradition came about after American regulations—spelled out in the Code Noir of 1724—prohibited marriage between blacks and whites.

Built in 1789 by Robert Jones, the house that stands on Dumaine Street today was not the first built on this site. In fact, the first home on this property was built in 1726 by Jean Pascal, a sea captain affiliated with the Company of the Indies, but it was destroyed in New Orleans' devastating 1788 fire. This home is one of the few surviving structures of another New Orleans fire in 1794.

Its French West Indies Colonial Creole design is a brick-between-post construction with segmented arch openings, exterior stairways, and a double-pitched, hipped, and dormered roof. The design includes a bricked lower floor and a wooden upper floor. The floor plan includes a living room, a dining room, a study, three bedrooms, and a back gallery. Slim wooden colonettes flank the wide second-floor galleries, which are considered a prototype of the "outdoor rooms" that help distinguish the overall character of French Quarter buildings.

The property also features a separate kitchen building with cooks' quarters and a two-story *garçonnière*, or service building. The buildings are separated by an L-shaped courtyard, which originally was a work space where household chores (e.g., laundry) were done. A lot next door was once the home of a formal parterre (garden with divided flower beds) and was part of the Madame John complex. Now a brick home sits in its place.

When Jean Pascal's widow, Elizabeth Real, and her new husband Francois Marin lived on the property in the mid-eighteenth century, the complex had two outhouses in back.

At the time of the 1788 fire, a Spanish military officer, Manuel DeLanzos, and his Panamanian wife, Gertrudis Guerrero, lived here with their six daughters. All survived the fire and, because he was a captain, DeLanzos was able to rebuild quickly. He chose immigrant builder Robert Jones—who did not construct the

home's dormers or the property's outbuildings—for the job.

After Captain DeLanzos died in 1812, his widow sold the house the following year to a lawyer from Brussels and his wife, who lived here with their children and slaves in great wealth. When they died, the possessions they left behind included gold and diamond jewels, an extensive library containing multilanguage volumes, one hundred or more bottles of wine and liquor, several pieces of silver, and four female slaves. The highest valued "item" among these was Manette, a thirty-nine- or forty-year-old slave who could be sold for $2,500 (presumably because of her experience as a "good cook, good laundress, good presser, dry plaiter, and good subject," according to family records).

In 1820, Madame Marie Louis Patin Roman bought the property. Her son Jacques Telesphore built Oak Alley Plantation, and her daughter was the mistress of Le Petit Versailles, the most refined and spectacular of plantations of the era. As was customary at the time, Roman probably traveled by riverboat to visit her children, establishing the link between life in town and life in the country.

In 1892, an Italian immigrant, Jean Baptiste Canepa, took ownership after a succession of previous owners. The grocer subdivided the property into several rental apartments. Canepa himself resided at the corner of Esplanade and Bourbon.

In later years, artist Morris Henry Hobbs, a noted engraver and onetime tenant of the apartments, created a popular engraving of the property. More images were created by other artists, and by 1947 the importance of the house and its history was recognized. At that time, its owner, Stella Hirsch Lemann, donated Madame John's Legacy to the Louisiana State Museum.

ABOVE: MADAME JOHN'S LEGACY IS DESIGNATED AS AN OFFICIAL NATIONAL HISTORIC LANDMARK. IT IS OWNED AND MAINTAINED BY THE LOUISIANA STATE MUSEUM, WHICH HAS CLASSIFIED THE HOME AS A LOUISIANA CREOLE RESIDENTIAL DESIGN.

BELOW: MADAME JOHN'S LEGACY, A WEST INDIES–STYLE HOME, ESCAPED THE GREAT FIRE OF 1794, WHICH LEVELLED MUCH OF NEW ORLEANS.

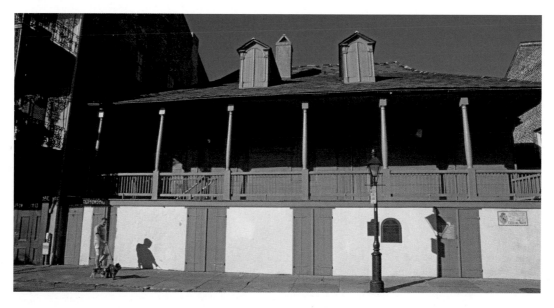

Beauregard-Keyes House

1113 Chartres Street

When designing the home now known as Beauregard-Keyes, architect François Correjolles had plans for a modified American townhouse that wound up becoming an enlarged Creole cottage with Greek Revival features. The Palladian façade resembles Italian architect Andrea Palladio's *Villa Foscari*, which exhibits a classic Greek temple front with pediment, portico, columns, and twin spiraling staircases. The double front doors are flanked by symmetrical side windows that match the transom above. Windows are double hung, and the interior features details like ceiling medallions, double French doors leading from one room to the next, a large parlor and ballroom, a rectangular dining room, and the Beauregard Chamber, furnished with original furnishings used by Confederate General Pierre Gustave Toutant Beauregard and his family.

BEAUREGARD-KEYES IS NAMED FOR TWO OF ITS MOST FAMOUS TENANTS: CONFEDERATE GENERAL P. G. T. BEAUREGARD (1818–1893) AND AUTHOR FRANCIS PARKINSON KEYES (1885–1970).

Wealthy auctioneer Joseph Le Carpentier commissioned the construction of the house (completed in 1826), and the next owner's wife, Anais Philippon Merle, created the formal parterre garden next to it. The garden was surrounded by a brick wall, which had a window so passersby could peek inside.

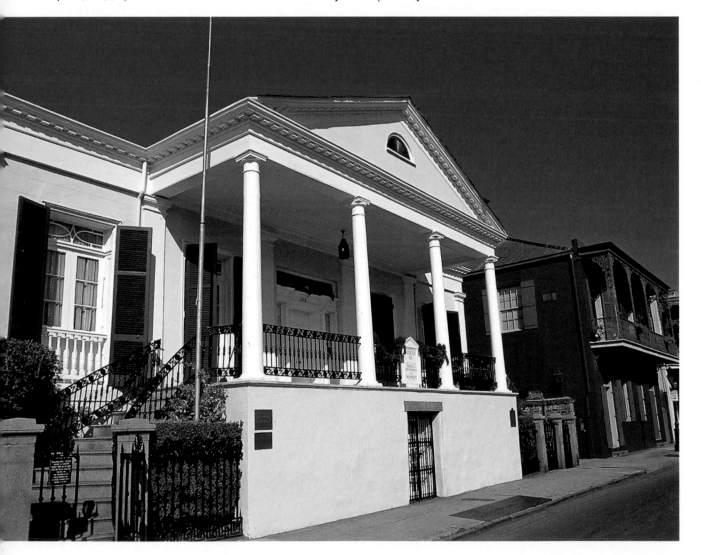

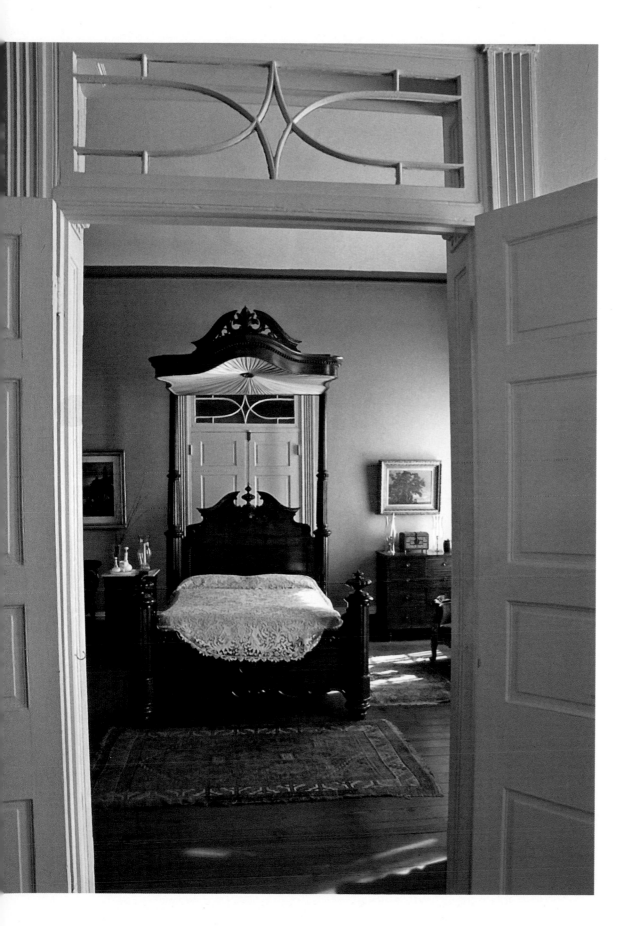

THE TRANSOM WINDOW VIEW OF THIS BEAUREGARD-KEYES BEDROOM SHOWS AN ANTIQUE TESTER BED. THE TRANSOM WINDOW ALLOWED HOT AIR TO CIRCULATE FROM ABOVE THE DOORWAY, A CRUCIAL DESIGN ELEMENT BECAUSE OF NEW ORLEANS' TROPICAL SUMMER TEMPERATURES.

By 1865, local grocer Dominique Lanata owned the house; he rented it out until 1904. His first tenants were the Beauregard family, who lived there until 1868. At the time, Beauregard was president of both the New Orleans, Jackson & Mississippi Railroad (1865–1870) and the New Orleans & Carrollton Street Railway (1866–1876). He was also an inventor: his 1869 cable clamp patent helped to create the cable-powered street railway cars—streetcars, not trolleys—the city is famous for.

While touring this placid, antique-furnished home today, you'd find it hard to believe it was once the site of a violent gun battle. But it was—in 1908, three people were killed in a mob showdown on the rear porch. The incident occurred when the Sicilian Black Hand tried to extort money from the new owner, wine merchant and *paisano* Corrado Giacona. Even though Giacona was from the same Mediterranean island as the organized-crime thugs, he would not stand for their brutality. It was Giacona who pulled the trigger, killing three of the would-be extortionists and wounding a fourth. Giacona was arrested but later released. The Giacona family sold the property in 1925 to Italian immigrant and importer Antonio Mannino. The house changed hands two more times until a famous author moved in.

The house is named for both General Beauregard and Frances Parkinson Keyes, who wrote more than fifty books in her lifetime, including one about the general. The widow of Senator Henry Wilder Keyes wrote a series of articles entitled "Letters from a Senator's Wife" in the 1920s for *Good Housekeeping*, which was published as a book of the same name. Although her book *Dinner at Antoine's* might be more recognized today, Keyes also authored a semifictional account of the life of Paul Morphy, grandson of the original owner of the house, Joseph Le Carpentier. Morphy was an international chess champion who wound up committing suicide. He is the subject of Keyes' *The Chess Players*.

In 1945, when Keyes was still a tenant at the Chartres Street property, she hired Richard Koch of Koch & Wilson Architects to devise restoration plans. Keyes also worked with the city's Garden Study Club to replant the home's parterre garden with magnolias, sculpted boxwoods, sweet olives, and cape jasmines, all of which would have been part of the gardens from the 1830s to the 1860s. Before this work could be done, though, the factory that had been moved into the garden's lot had to be demolished. Bricks from this structure were salvaged to build the garden's walls. Behind these walls today is a cast-iron fountain.

Keyes was a sophisticated world traveler and collector. She had numerous antique dolls, costumes, fans, and rare porcelain *veilleuses*, a style of teapot in which the contents are warmed by a small votive light. All are now on display in the museum.

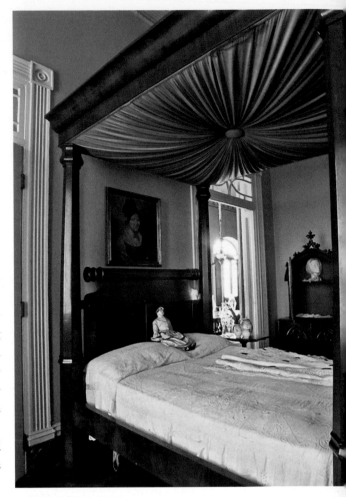

ABOVE: THIS BEAUREGARD-KEYES BEDROOM DISPLAYS AN ANTIQUE DOLL BELIEVED TO HAVE COME FROM AUTHOR FRANCIS PARKINSON KEYES' DOLL COLLECTION.

FACNG PAGE: GENERAL BEAUREGARD RESIDED HERE FROM 1866 TO 1868, WHEN HE WAS A RAILROAD PRESIDENT. HIS SON, RENE BEAUREGARD, IS ASSOCIATED WITH THE MALUS-BEAUREGARD HOUSE IN NEARBY CHALMETTE.

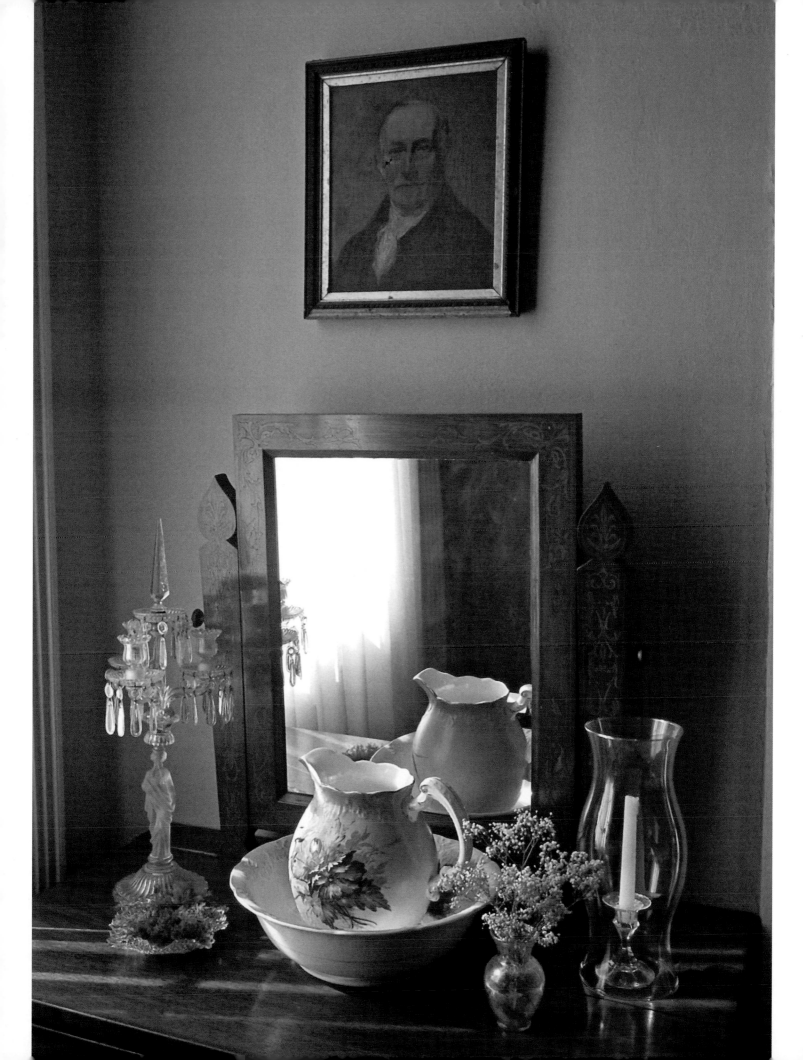

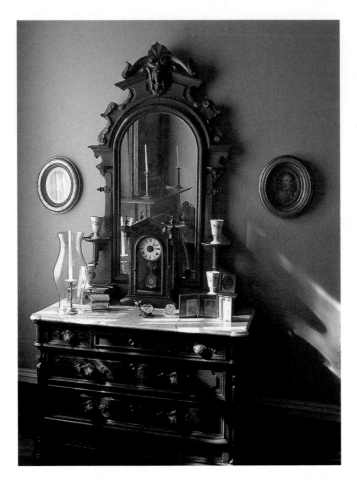

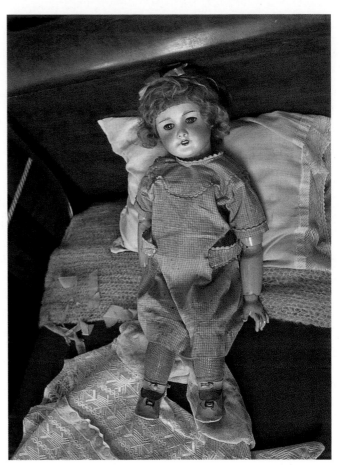

AN ANTIQUE MARBLE-TOP BEDROOM DRESSER AND
MIRROR IN THE BEAUREGARD-KEYES HOUSE. THE
HOUSE WAS BUILT IN 1826 FOR AUCTIONEER JOSEPH
LE CARPENTIER.

AN ANTIQUE DOLL FROM FRANCIS PARKINSON KEYES'
COLLECTION, WHICH NUMBERS MORE THAN TWO
HUNDRED.

FACING PAGE: THE BEAUREGARD-KEYES HOUSE PUTS OUT THE DOLL COLLECTION EACH CHRISTMAS, POSING THE
DOLLS IN A TEA PARTY SETTING.

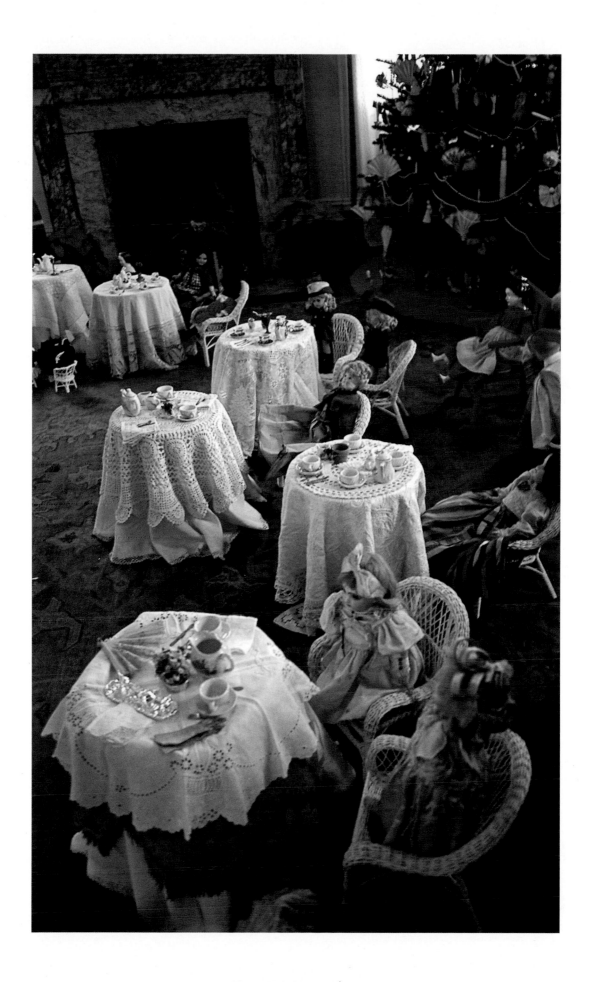

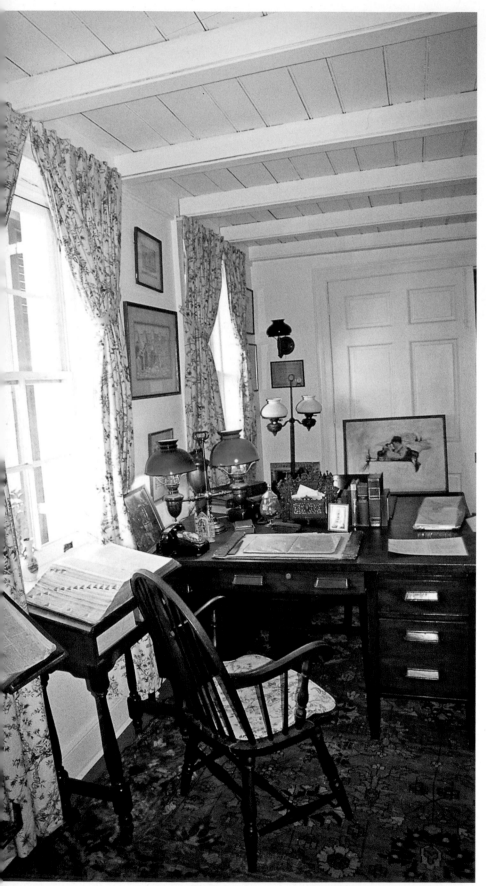

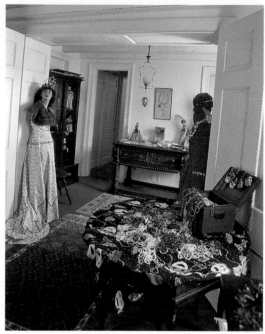

ABOVE: THE BEAUREGARD-KEYES HOUSE
DRESSING AREA SHOWS PART OF AUTHOR
FRANCIS PARKINSON KEYES' COSTUME
COLLECTION. SHE MOVED INTO THE
HOUSE IN THE 1950S, RESCUING IT FROM
DISREPAIR.

LEFT: THIS IS THE DESK AND TYPEWRITER
WHERE FRANCIS PARKINSON KEYES WROTE
DINNER AT ANTOINE'S. THE NEW ORLEANS
RESTAURANT ANTOINE'S, WHICH SERVES AS
THE BOOK'S SETTING, HAS BEEN IN BUSINESS
SINCE 1840 AND IS LOCATED AT 713 RUE
SAINT LOUIS.

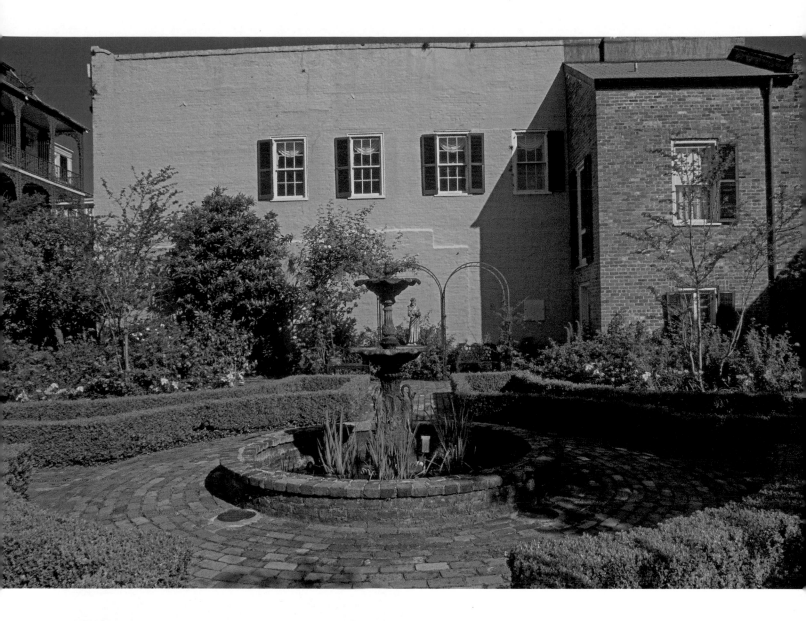

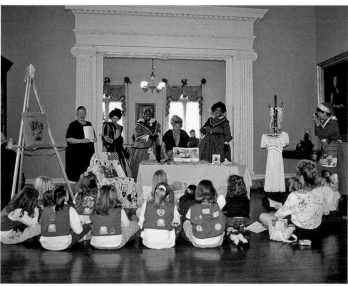

ABOVE: THE SIDE COURTYARD GARDEN AT THE BEAUREGARD-KEYES HOUSE IS HOME TO A CAST-IRON FOUNTAIN AND IS A FORMAL PARTERRE GARDEN. A PARTERRE GARDEN IS COMPOSED OF PLANTING BEDS, EDGED IN STONE OR TIGHTLY CLIPPED HEDGING, AND GRAVEL PATHS ARRANGED TO FORM A SYMMETRICAL PATTERN.

LEFT: A GIRL SCOUT TROOP VISITS THE BEAUREGARD-KEYES HOUSE AND PARTICIPATES IN THE TEA PARTY HOSTED BY FRANCES PARKINSON KEYES' DOLLS. THE AUTHOR WAS ALSO AN AVID COLLECTOR OF COSTUMES, FANS, AND TEAPOTS.

Hermann-Grima Historic House

This elegant Federal residence is a testament to the wealth of the man who commissioned it, Samuel Hermann Sr., a successful Jewish banker and merchant born in Roedelheim, Germany. He settled initially along the German Coast of what is now Saint John Parish, where he met his Creole Catholic wife, a widow named Marie Emeranthe Brou. Their daughter, Marie Virginie, was a day student at the nearby Ursuline Convent school after they moved in.

The house was designed and completed in 1831 by American architect William Brand, who incorporated a center hall beyond the front entrance, a new feature not seen in earlier Creole houses where the rooms all open into each other. Small rooms—or "cabinets," borrowed from the French Creole building tradition— were included on both floors and were used for many purposes, such as dressing rooms or nap rooms with daybeds (which were also used to isolate the sick).

In a letter written by Carl Kohn, a nephew of a friend of the Hermanns, he mentions a grand soirée the family hosted at the house. He writes that most of the 350 invited guests attended, but bad weather prevented a planned elaborate fireworks display.

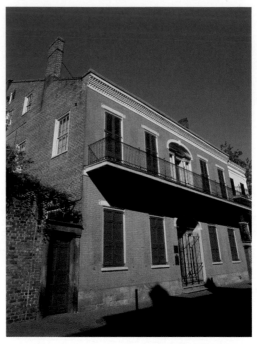

THE FEDERAL-STYLE (OR AMERICAN) FAÇADE OF THE HISTORIC HERMANN-GRIMA HOUSE IS UNUSUAL FOR THE FRENCH QUARTER, WHERE CREOLE STYLES PREVAIL.

Samuel Hermann hosted many parties, but unfortunately, he lost more than a million dollars during the Panic of 1837 and was forced into bankruptcy in 1844. So much for elegance—his family had to move.

Felix Grima Sr., an attorney and judge, and his wife, Marie Sophie Adélaide Montegut Grima, became the next owners in 1844. They added the stables to the property. The native New Orleaneans lived here with nine children, Felix's unmarried sister Francoise, and his elderly, widowed mother.

When the widow died at ninety-six, her coffin was placed in the parlor in front of the fireplace for the wake, as was the custom of the day. When mourners arrived to pay their respects, they were greeted by a somber black wreath at the front door. The clocks inside were set to the hour of the deceased's death, and mirrors were covered with dark drapes. People believed that if left uncovered, a vision of the deceased would appear in them, or that any shiny surface would attract evil spirits.

When Felix Grima refused to sign an oath of loyalty to the Union during the Civil War, he and his family fled to Augusta, Georgia. The house was shuttered, but the family eventually returned, and subsequent Grima family members resided here until 1921. In 1924, the house was renovated by the Christian Women's Exchange to provide rented rooms for single women in need. Following an organizational mission change from charity to education around 1965, the Christian Women's Exchange began to restore the house to its nineteenth-century appearance.

Visitors that come to the Hermann-Grima Historic House museum will find that the home now showcases a well-to-do lifestyle from 1830 to 1860. It has been completely restored to its original 1830s style. A fan-lit entrance leads to the central hall and side parlors and bedrooms. The rear center hallway

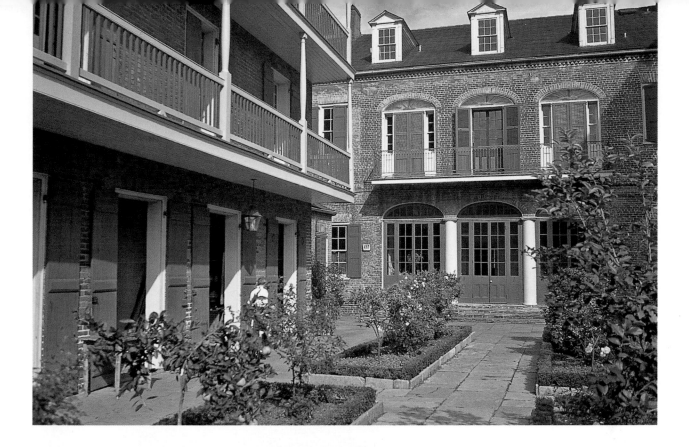

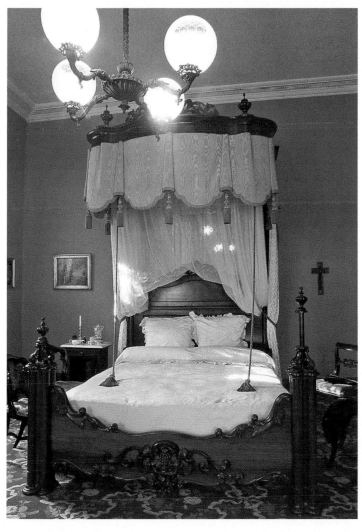

ABOVE: THE HERMANN-GRIMA HOUSE COURTYARD SHOWS THE PROPERTY'S BALCONY-TIERED SLAVE QUARTERS, WHICH WERE SITUATED ABOVE THE FIRST-FLOOR KITCHEN. THE BACK OF THE MAIN HOUSE IS IN THE FOREGROUND, BEYOND THE DIVIDED BRICK PATH.

LEFT: FELIX GRIMA'S WIDOWED MOTHER SLEPT IN THIS BEDROOM WHEN SHE MOVED INTO THE HOME AT THE AGE OF NINETY.

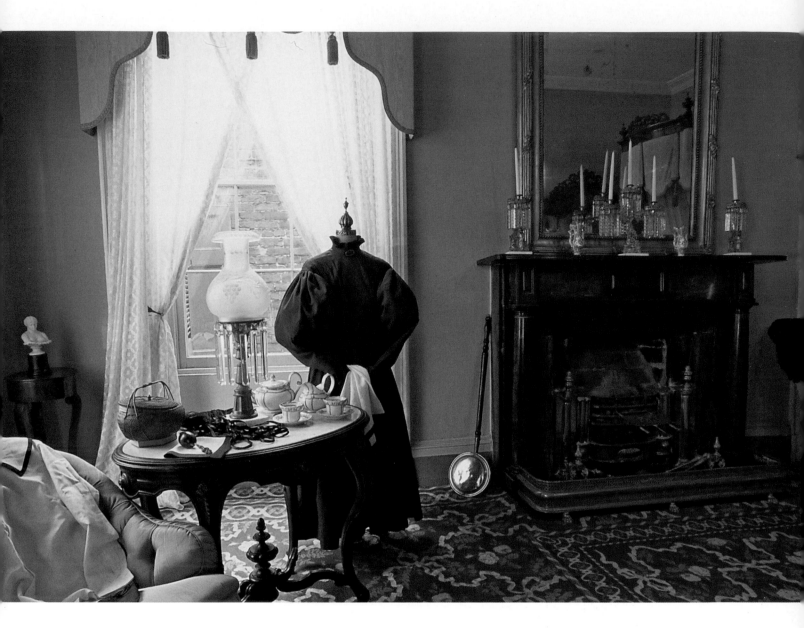

THIS BLACK DRESS IS ONE THAT WOULD HAVE BEEN WORN DURING MOURNING AND IS PART OF THE HERMANN-GRIMA HOUSE'S DISPLAY OF HOW A HOME WOULD HAVE LOOKED IN THE 1800S DURING A WAKE. AT THE TIME, CASKET VIEWINGS WERE HELD IN PRIVATE HOMES.

showcases a graceful, curving staircase. Furnishings include American Empire and Rococo Revival pieces chosen by the National Society of Colonial Dames in Louisiana to reflect the representational taste and style of the Hermann and Grima families. The parlor boasts an unusual square, English Gunther & Horwood pianoforte, which was a kind of piano/harpsichord/clavichord. Upstairs, the library still boasts Felix Grima's book collection shelved within two original bookcases once used by the notary who became a judge.

The separate three-story service building, or *garçonnière*, exhibits rooms that include servants' quarters for the slaves of the families, a washing room where laundry was done, an ironing room, and a wine room. The building also has an expansive, period open-hearth kitchen, where visitors can see bubbling pots suspended over a flame by a swinging crane.

In fall, the museum is decorated as if in mourning, as it was for the widow's wake so many years ago.

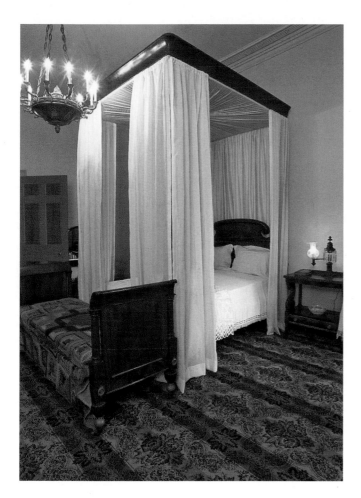

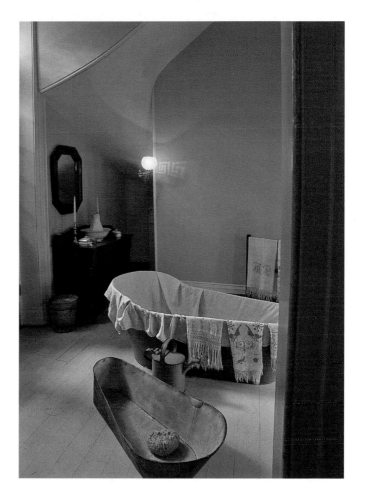

THE HERMANN-GRIMA HOUSE HAS FIVE BEDROOMS, INCLUDING THE ONE PICTURED HERE THAT FEATURES A BED THAT BELONGED TO THE GRIMA FAMILY. THE HOME ALSO HAS A HORSE STABLE AND FUNCTIONAL 1830S OUTDOOR KITCHEN.

A REAR CABINET—A SMALL ROOM LOCATED LIKE A BOOKEND IN THE BACK CORNER OF A HOUSE—WAS DESIGNATED AS A BATHING ROOM ON THE FIRST FLOOR OF THE HERMANN-GRIMA HOUSE. THE ROOM'S LOCATION UNDER THE STAIRWELL CAN BE OBSERVED BY THE TELLTALE ASCENDING PROTRUSION IN THE CEILING.

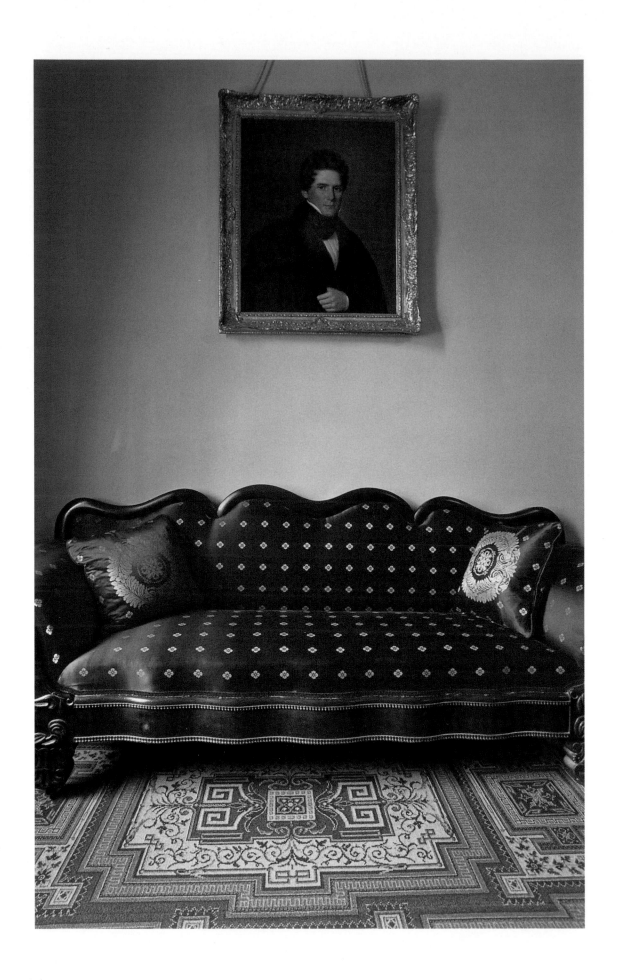

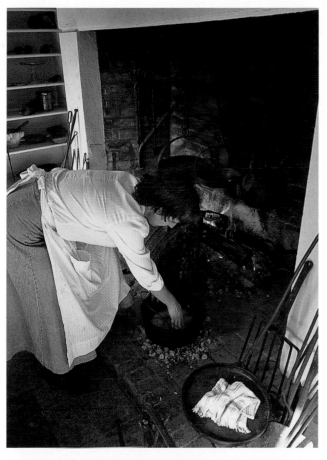

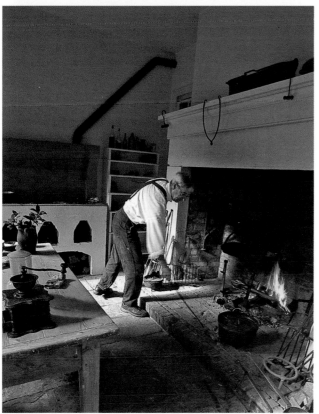

ABOVE: IN THE 1830S, THE MAIN MEAL WAS SERVED BETWEEN 2 P.M. AND 4 P.M. AND FEATURED TWO OR THREE MAIN COURSES WITH ANYWHERE FROM FOUR TO TWELVE DISHES PER COURSE.

LEFT (TOP & BOTTOM): FREQUENTLY, THE HERMANN-GRIMA HOUSE HOSTS DEMONSTRATIONS IN ITS 1830S-ERA KITCHEN, SHOWING HOW COOKING WAS DONE IN THE DAYS BEFORE ELECTRICITY. VISITORS ALSO LEARN ABOUT NEW ORLEANS' DISTINCTIVE CUISINE, WHICH INCLUDES A BLEND OF AFRICAN, FRENCH, AND NATIVE AMERICAN CULTURAL INFLUENCES.

FACING PAGE: FELIX GRIMA, A JUDGE AND NOTARY WHO WAS ORIGINALLY FROM MALTA, BECAME THE SECOND OWNER OF THIS HOUSE IN 1844 (HIS PORTRAIT IS SEEN ABOVE THE RED COUCH IN THIS PHOTO). FIVE GENERATIONS OF GRIMAS LIVED IN THE HOUSE.

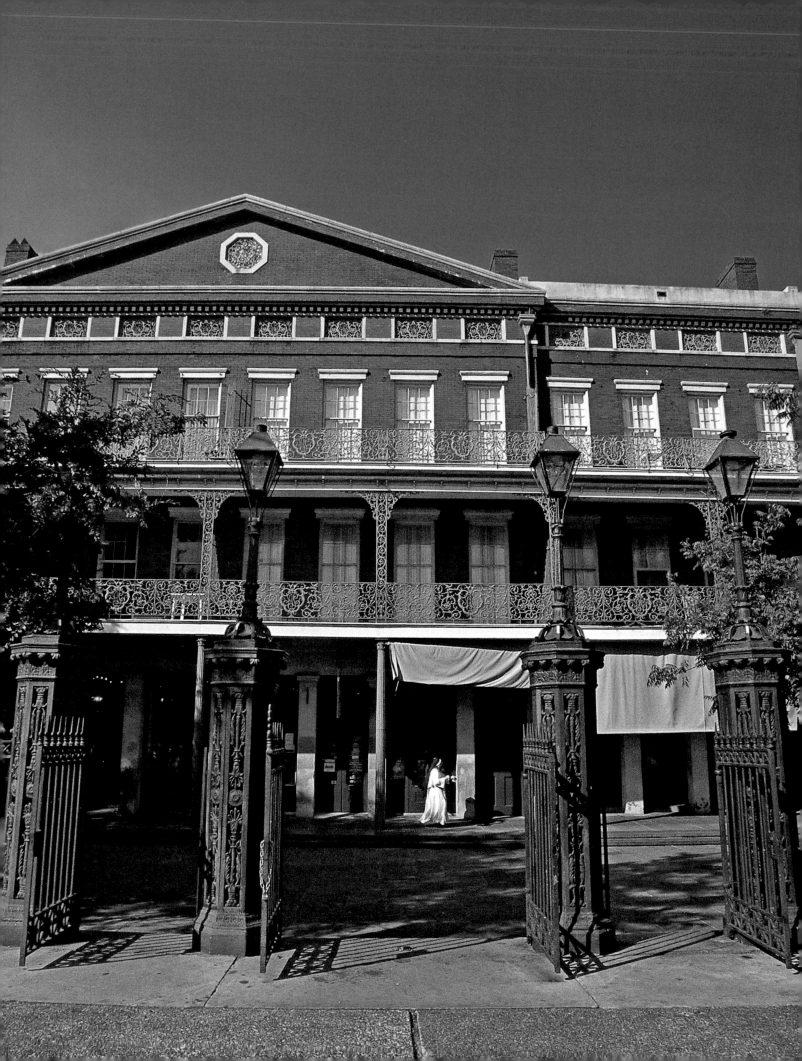

1850 House, the Lower Pontalbas

A strong woman with a tumultuous family life was the impetus for building the elegant Pontalbas, distinctive, mid-nineteenth-century, Greek Revival row houses that flank Jackson Square. Baroness Micaëla Almonester de Pontalba was the daughter of a French Creole woman and Don Andres Almonester y Roxas, a wealthy Andalusian notary and philanthropist who financed the reconstruction of the St. Louis Cathedral and the Cabildo. He died when she was just two.

THE 1850 HOUSE IS A RE-CREATED ANTEBELLUM TOWNHOUSE LOCATED IN THE LOWER PONTALBA BUILDING.

When she was fifteen, she married her cousin "Tin-Tin," and she was whisked away to France, where she repeatedly had to protect her inherited fortune from her father-in-law, Baron Joseph Xavier Delfau de Pontalba. When she was expecting her first child, the baron pushed hard for her to sign a contract giving him all her money, should she die in childbirth. "Mais non!" she replied, refusing to sign the document. After twenty-three years of haggling with her husband and in-laws over her property, she wanted a divorce, which especially angered the baron. In 1834, he was so fed up that he shot her with a pistol, hitting her in the chest four times. She covered her heart with her palm but was seriously wounded, losing two fingers. She managed to escape, and her father-in-law committed suicide with the pistol moments later.

After a long recovery, Micaela returned to her native soil in 1849 with some very specific ideas for developing the prime New Orleans real estate she had inherited from her father. Situated on the right and left of the Place d'Armes across from the river and the cathedral, the property was smack in the center of town. The baronness decided to construct an upper (toward uptown) and lower (in the opposite direction) row of sixteen four-story townhouses facing the square like bookends. The individual residences would have their own indoor toilets, street and rear service entrances, inside staircases, and upper balconies accessible by high, opening guillotine windows. The overall exterior design concept most closely resembled Paris' Place des Vosges, with commercial shops on the ground floors facing a square.

Samuel Stewart, contractor for the Pontalbas, puzzled over incompatible directions and constant changes in the working drawings. But the baroness, who considered herself a builder, did not back down from her numerous requests for detailed revisions. She did have some experience in these matters: she was an architectural designer with on-the-job training constructing another building in Paris, the Hotel Pontalba (now the U. S. embassy).

For the Pontalba buildings, the baroness came up with the design for their columns, found their versatile interior shutters, and either she or her artist son Gaston designed the scripted "AP" (for Almonaster and Pontalba) monogram for the elaborate, French ornamental cast-iron balcony. (This superseded the traditional hand-worked wrought iron of the French Quarter.) Almost everything for the project was ordered from manufacturers' mail-order catalogs. The Pontalba buildings represent the first major American use of industrially produced and distributed building materials. Bricks were from Baltimore, plate glass was from England, and granite and ornamental iron were from New York.

Attracting tenants to the distinctive townhouses was no problem. Famous singer Jenny Lind rented one for a month in January 1851 when she toured New Orleans, and the publicity surrounding her new residence was extensive.

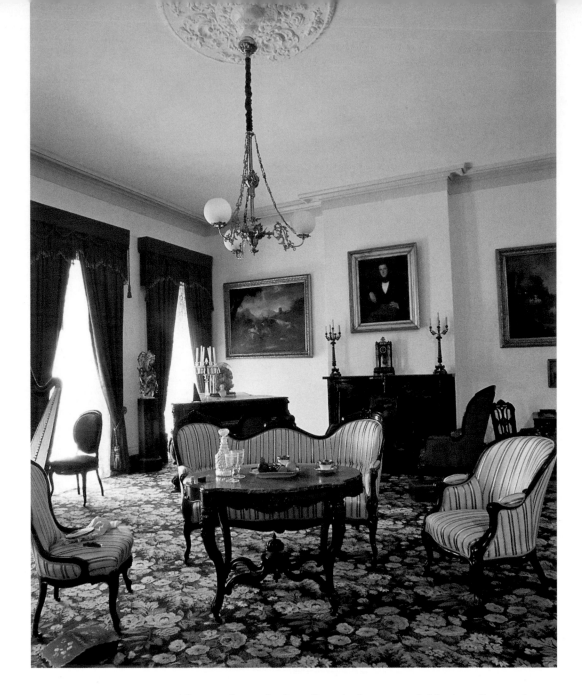

After completing the Pontalbas, the baroness sailed back to Paris and never returned to New Orleans. She is buried on the grounds of the Château Mont-l'Évêque in France, next to her ex-husband, the son of the man who tried to kill her.

By the early 1900s, the Pontalbas had been subdivided into apartments, and by the 1920s, their decaying elegance attracted writer Sherwood Anderson as a tenant. Other writers and artists who lived here include Katherine Anne Porter and Clarence John Laughlin.

In 1921, the Pontalba family sold the Lower Pontalba building to philanthropist William Ratcliff Irby, who bequeathed it to the Louisiana State Museum in 1927. The museum is a complex of national landmarks throughout the state, housing thousands of artifacts and works of art reflecting Louisiana's historic events and cultural diversity. The museum operates ten properties in the French Quarter, including the Cabildo, the Presbytére, the 1850 House, the Old U.S. Mint, and Madame John's Legacy. The 1850 House is the museum part of the Lower Pontalbas, but the first floor of both upper and lower buildings houses shops and restaurants that are open to the public.

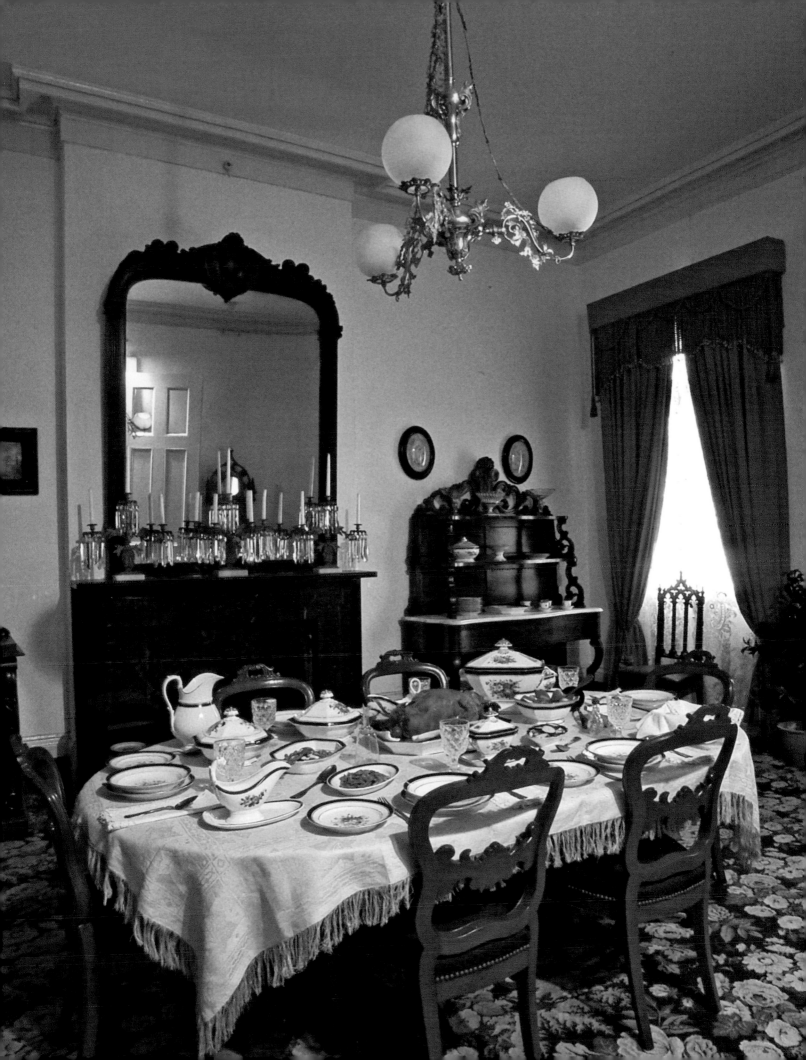

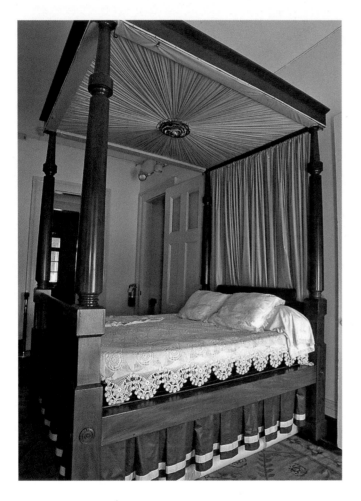 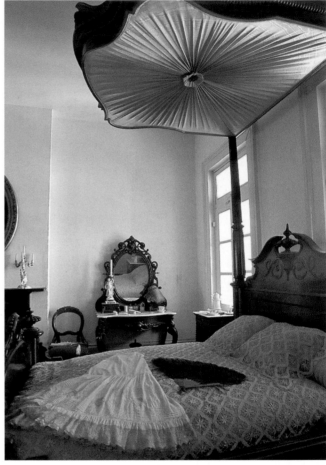

A BEDROOM FURNISHED IN A STYLE POPULAR IN THE
1850S. THE LADY OF THE HOUSE AT THIS TIME KEPT
HOUSEHOLD ACCOUNTS AND MET WITH VENDORS
WHILE SUPERVISING THE HOME'S COOKING AND
CLEANING.

THE 1850 HOUSE IS A NATIONAL HISTORIC LANDMARK.
THE MUSEUM AND FIRST FLOOR SHOP ARE RUN BY THE
LOUISIANA STATE MUSEUM.

FACING PAGE: MIDDLE-CLASS CHILDREN IN THE 1850S WOULD HAVE PLAYED WITH THEIR
TOYS IN THE PRIVACY OF A BEDROOM, NEVER A PARLOR.

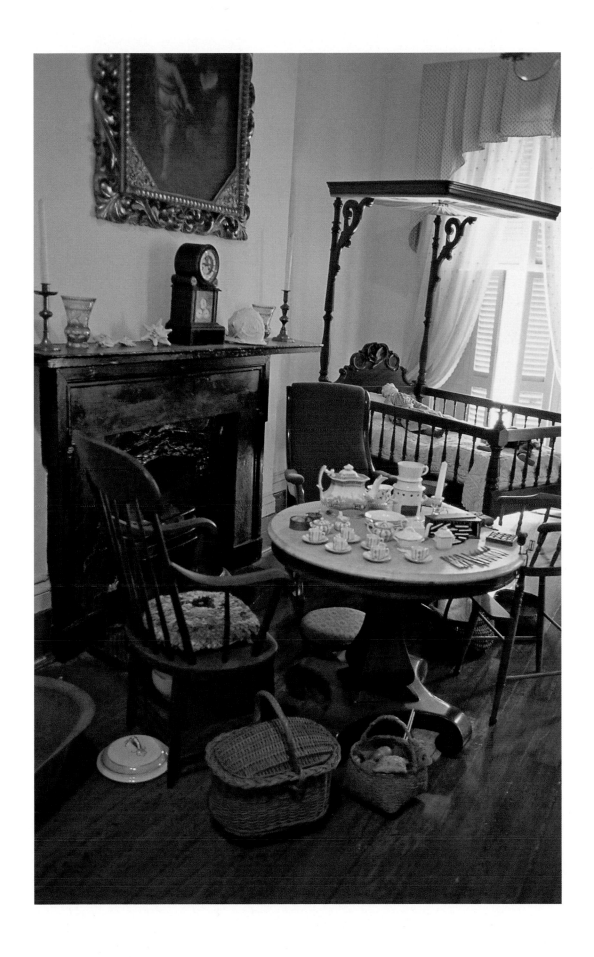

Gallier House

James Gallier Jr. knew how to build houses. After all, he had worked with his father, James Gallier Sr., who built many New Orleans landmarks, including Gallier Hall, the large columned building on St. Charles Avenue that resembles a Greek temple. In fact, Gallier Hall was inspired by the north porch of the Athens Erechtheum on the Acropolis in Greece.

When the elder Gallier retired in 1849, he set up his twenty-two-year-old son with a partnership joining two of his former associates. While his father traveled with his new wife on extended vacations to exotic ports of call, Gallier Jr. busied himself with drawing up plans for the Pontalba buildings. But the baroness commissioning them scoffed at his ideas and dismissed him from the project. Regardless, the young builder persevered and eventually completed some of New Orleans' most iconic structures: his own home and the Leeds Iron Foundry, from which so many wrought-iron balconies originated.

After marrying in 1853, the young Gallier and his wife Josephine Aglaé Villavaso lived on Royal Street in various houses until their own home was constructed between 1857 and 1859 at 1132 Royal Street. No expense was spared on the home, which has a façade that combines Italianate details (such as the stucco exterior) with such classical elements as the formal front entrance.

The exterior of the home resembles granite, but the finish is faux. It's really brick with a gray stucco layer on top. The front door's exterior is walnut, and the interior is faux oak (a more costly wood at the time). Such painting techniques, called *trompe l'oeil* (French for fool the eye), were fashionable at the time. Even inside wooden baseboards have been painted to resemble the Egyptian marble of the mantels. The unusual cast-iron, front-door gate was painted in Paris Green, a popular local hue at the time. Windows were positioned for maximum airflow, and louvered shutters still allowed ventilation even when closed. As was customary, ceilings were twelve feet high, allowing warm air to rise above the heads of the home's occupants.

A cast-iron gallery extends the length of the façade, supported by slim cast-iron columns, framed with iron lace in a rosebud pattern on the second floor. The first-floor front entrance opens into a small vestibule featuring fluted wooden Corinthian pilasters with a full entablature. Along the hallway there is a gas-burning fixture with a smoke bell (rung to avoid blackening the plasterwork above). The hallway leads to the double parlor, divided by a sliding door, where the Gallier family relaxed and entertained. Here, elegant period items approximating those owned by the Galliers are displayed. They include a lacquer game table with mother-of-pearl inlay and a rosewood *méridienne* (a half sofa designed to accommodate hoop-skirted ladies sitting in a side-saddle position). The style of this triple-arch sofa is mostly Rococo Revival, made by or in the style of John Henry Belter, a famous New York cabinetmaker of the time.

INSET: THE LATE-AFTERNOON SUN SHADOWS THIS GALLIER HOUSE STREET SCENE ON ROYAL STREET IN THE FRENCH QUARTER, OR VIEUX CARRÉ. THIS LOWER END OF THE QUARTER IS THE MORE RESIDENTIAL END, WITH STREETS HEADING TO ESPLANADE AND THE FAUBURG MARIGNY. ROYAL STREET GOING THE OTHER WAY TOWARD CANAL IS MORE COMMERCIAL, HOME TO GALLERIES, SHOPS, AND CAFÉS.

FACING PAGE: GALLIER HOUSE GUIDES DRESS AS HISTORICAL CHARACTERS FOR AN ANNUAL CHRISTMAS IN NEW ORLEANS CELEBRATION AT THE HOME. GALLIER HOUSE WAS THE HOME BUILT BY AND FOR ARCHITECT JAMES GALLIER JR. IN 1857. GALLIER WAS ONE OF NEW ORLEANS' MOST PROMINENT ARCHITECTS IN THE MID-NINETEENTH CENTURY.

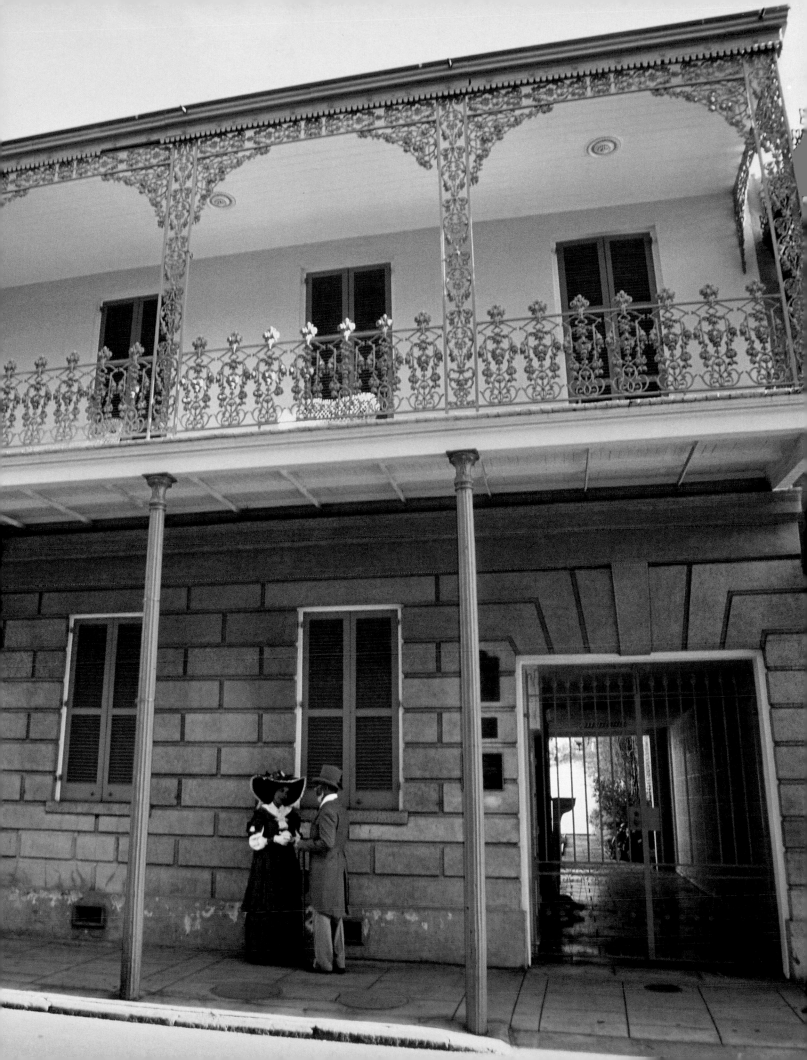

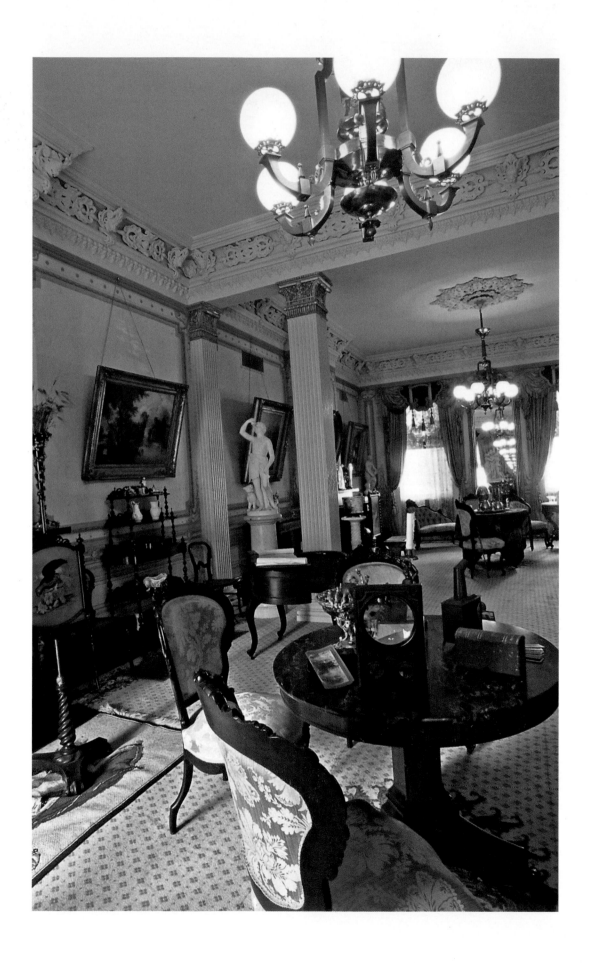

A 1971 archaeological investigation (the first in the French Quarter) of the Gallier Home revealed coins from 1773, 1799, and 1842; crystal porcelain and pottery fragments; toothbrushes, bottles, and wine seals; and even bones. Although none of these items could be directly attributed to either the Galliers or the Ursulines who owned the lot before them, curators used the information to purchase period household goods for display.

The home also has several marble statues and a Pleyel piano from France. On the walls are portraits of family members and landscapes in oil. The townhouse plan contains the principal living spaces (parlors, bedrooms) near the street entrance, with the back wing containing the dining room, unusual inside kitchen, pantries, and separate back building for slave quarters. Upstairs are bedrooms that the Galliers' four daughters shared and a bathroom complete with indoor plumbing.

Another luxury the Galliers enjoyed was located downstairs on the back gallery: the ice box. Most homes in New Orleans didn't have one until the 1870s. The Gallier girls were no doubt very popular when they served ice cream, sherbets, and iced drinks to their guests.

In 1866, the Galliers were saddened by the sudden death of James Sr. and his wife. They perished when the steamship *Evening Star* sank in a hurricane off Cape Hatteras, North Carolina. As a fitting final resting place, James Jr. designed a scroll-themed tomb in St. Louis No. 3 Cemetery on Esplanade. It is the same resting place for the younger Gallier, who died unexpectedly in his home in 1868.

Today, Gallier's Victorian home is a museum with period furnishings throughout, including a Mallard bedroom suite in the master bedroom. As was the custom in the mid-1800s, the house dons its "summer dress" each season, where visitors will see the heavy upholstery covered with white linen slipcovers, windows with linen shades instead of heavy draperies, and straw mats used in an effort to keep the house cool. Now if only ice cream was served.

FACING PAGE: THE GALLIER HOUSE OPENED AS A MUSEUM IN 1971, FOLLOWING TWO YEARS OF RESTORATION. AFTER THE GALLIER FAMILY SOLD THE HOUSE IN 1917, THE HOME FELL INTO DISREPAIR. THANKFULLY, MOST OF THE CHANDELIERS, CORNICES, MANTELS, PLASTER WORK, WALLS, AND WOODWORK HAVE SURVIVED.

Gallier-Designed Buildings

In addition to his own home, several buildings James Gallier Jr. built in New Orleans are still standing. They include the following:

LEEDS IRON FOUNDRY (STORE AND WAREHOUSE)
circa 1852
923 Tchoupitoulas Street
(now the Preservation Resource Center)

DOUBLE STORE FOR ROBERT HEATH
circa 1855
St. Charles and Gravier streets

HOUSE FOR LAVINA DABNEY
circa 1856
2265 St. Charles Avenue

HOUSE FOR FLORENCE A. LULING
(Former Louisiana Jockey Club), circa 1865
1436 Leda Street

GATES AND GATEHOUSE FOR THE FAIRGROUNDS RACETRACK
circa 1866
1751 Gentilly Boulevard

Gone but Not Forgotten:
FRENCH OPERA HOUSE
Bourbon and Toulouse streets
Constructed 1859, burned 1919

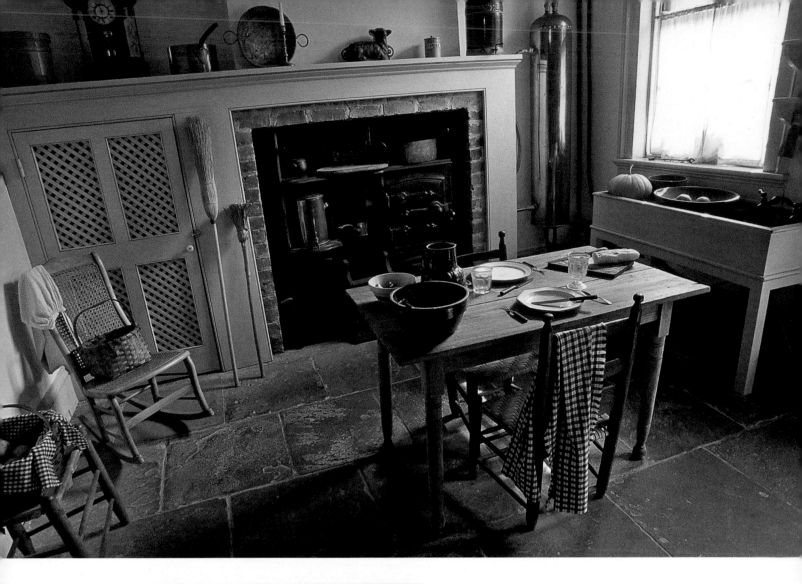

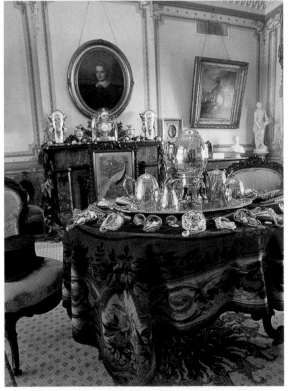

ABOVE: THIS WAS A MODERN KITCHEN FOR 1860 BECAUSE IT HAD A HOT AND COLD RUNNING-WATER SYSTEM AND A CAST-IRON COAL-BURNING RANGE, WHICH DIRECTED HEAT AND ODORS UP THE CHIMNEY. THIS ALLOWED THE PLACEMENT OF A KITCHEN TO BE INDOORS RATHER THAN IN AN OUTBUILDING.

LEFT: A GALLIER HOUSE PARLOR TABLE DECORATED FOR A NEW YEAR'S EVE CELEBRATION. THE MANSION'S FRONT DOUBLE PARLORS WERE USED FOR GAMES AND ENTERTAINING.

FACING PAGE: THE GALLIER HOUSE SECOND-FLOOR LIBRARY WITH DESKTOP ARCHITECTURAL TOOLS. JAMES GALLIER'S FIRM, GALLIER AND TURPIN, BUILT THE LEEDS FOUNDRY AT 923 TCHOUPITOULIS STREET IN 1853. IT'S NOW THE PRESERVATION RESOURCE CENTER OFFICE.

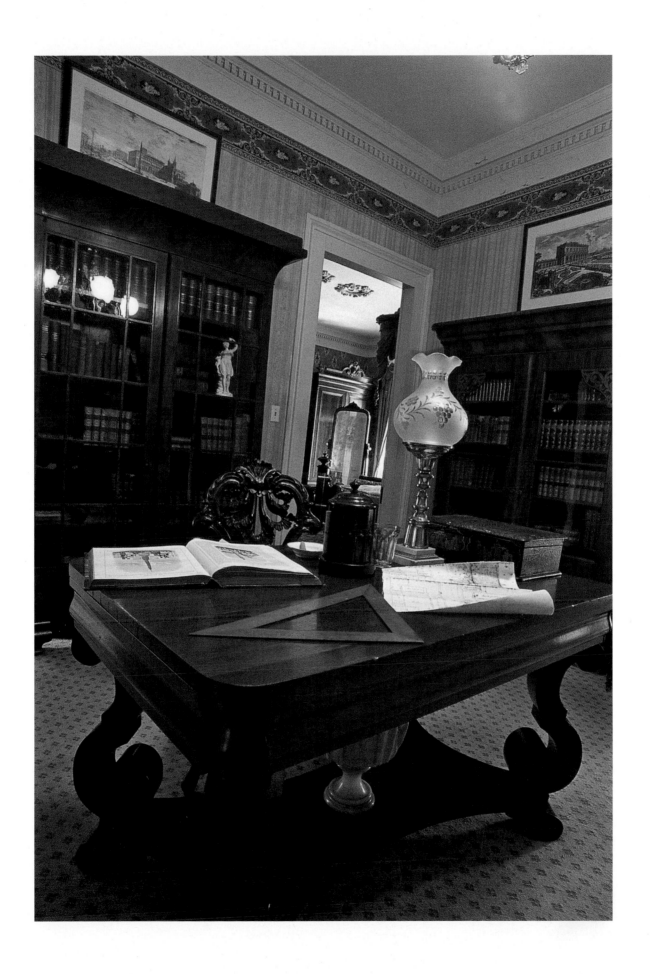

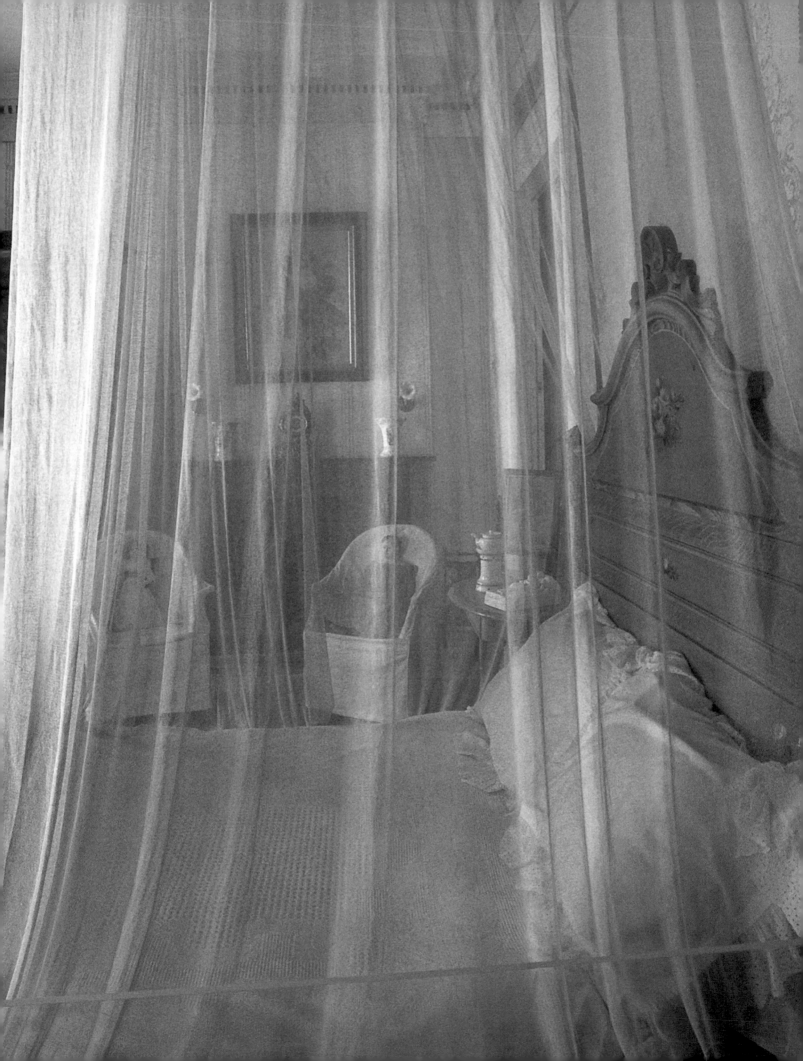

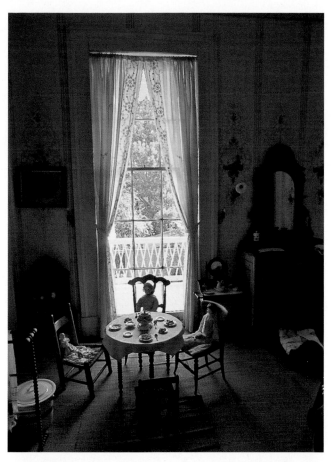

FACING PAGE: ONE OF THE CHILDREN'S BEDROOMS IN THE GALLIER HOUSE, COMPLETE WITH A MOSQUITO NETTING–COVERED BED. THE GALLIERS HAD FOUR DAUGHTERS, ALL OF WHOM GREW UP IN THE HOUSE. THEY WERE ELIZABETH LEONIE (1853–1924), JOSEPHINE BLANCHE (1856–1933), FRANÇOISE JOSEPHINE (1858–1909), AND JEANNE CLEMENCE (1860–1941).

LEFT: A GALLIER HOUSE CHILDREN'S BEDROOM, WITH DOLLS AT A TABLE SET FOR A TEA PARTY. IT IS BELIEVED THAT TWO OR MORE OF THE GALLIER DAUGHTERS SLEPT IN THIS ROOM.

BELOW: A GALLIER HOUSE LIVING HISTORY DAYS EVENT PHOTO SHOWS A CLOSEUP OF A NEEDLEPOINT FEATURING A PATRIOTIC MOTIF. THE MUSEUM'S TRAINED VOLUNTEERS DEMONSTRATE NINETEENTH-CENTURY HOUSEHOLD TASKS—INCLUDING SEWING, BUTTER CHURNING, FABRIC DYING, TIGNON TYING (A POPULAR CREOLE HAIRSTYLE), AND WOODWORKING—DURING THESE EVENTS.

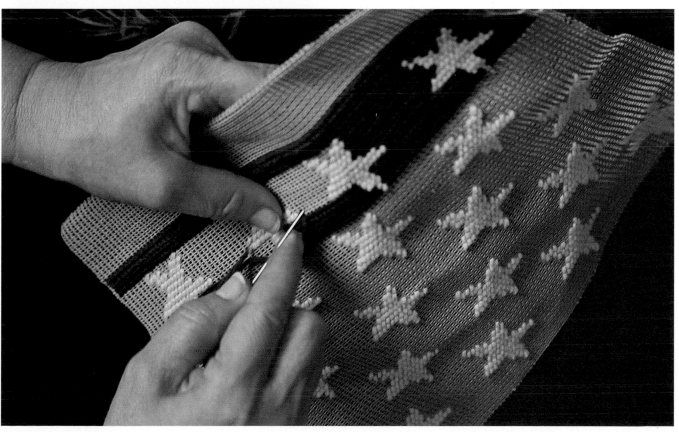

RIGHT: A GALLIER HOUSE SLAVE QUARTERS BEDROOM SHOWING TWIN BEDS AND A STOVE. THE BEDS ARE STUFFED WITH SPANISH MOSS AND DUCK FEATHERS. THE STOVE BURNED WOOD.

FACING PAGE: IN STARK CONTRAST TO THE MAIN HOUSE, THIS SLAVE QUARTERS BEDROOM SHOWS THE AUSTERE REALITY OF THEIR PRIVATE SPACE.

BELOW: AN ANTIQUE BUTTER CHURN, BUTTER, AND BREAD LOAF COMPLETE THIS GALLIER HOUSE STILL LIFE.

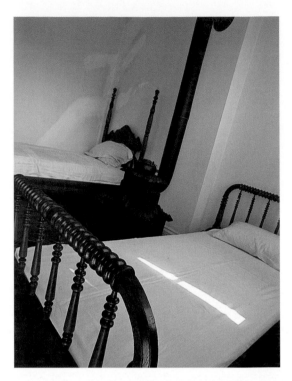

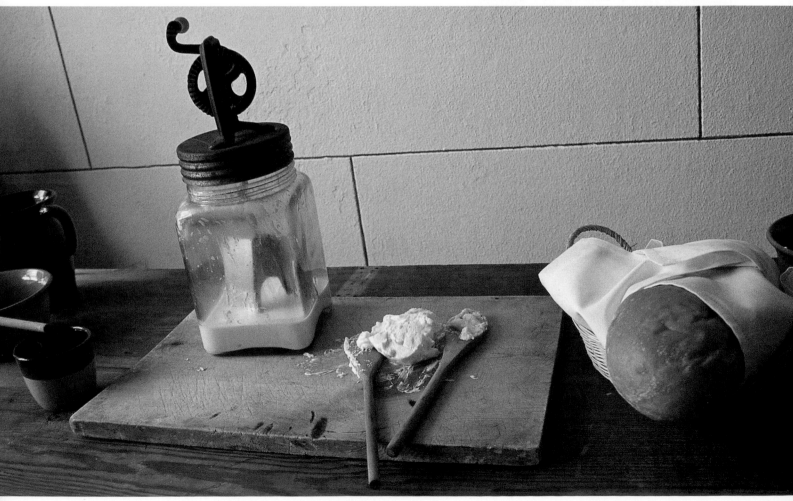

Faulkner in New Orleans

"The past is never dead. In fact, it's not even past."
— *Requiem for a Nun*, William Faulkner

Nobel Laureate and Mississippi-born author William Faulkner (1897–1962) never owned a house in New Orleans, but he did rent an apartment in an alley behind the Cabildo in the French Quarter in 1925. It was here, at 624 Pirate's Alley (behind St. Louis Cathedral in Jackson Square), where he wrote his first novel, *Soldiers' Pay*.

The building on Pirate's Alley is part of a row of eleven houses that wrap around Royal Street to St. Peter Street. The row of houses was built in 1840 for Malasie Trepagnier, the widow of Jean-Baptiste LaBranche, a wealthy sugar planter on the German Coast. The buildings are collectively known as the LaBranche buildings. The Royal Street elevation displays an oak-and-acorn motif in wrought iron, which is fitting in that *la branche* means twig in French. It was added after 1850.

Although this setting played no role in Faulkner's fictional story of World War I disillusion, he did write *Soldiers' Pay* here. He sublet his first floor apartment from William Spratling, an architect, painter, and writer.

Faulkner was also published by a New Orleans journal, *The Double Dealer*, founded by a group of talented New Orleans poets responding to a description of New Orleans as a cultural wasteland by Baltimore satirist H. L. Mencken. The journal's title had a surrealist theme, which implied a double existence (as opposed to cheating or double-crossing).

Faulkner also seemed to have a double existence. One was as a respected writer (which came later) and another as an often barefoot drinker who convinced his fellow Quarterites that he was a fighter pilot in World War I and that he had been shot down in battle, but survived. The truth was that he had never seen action.

While Faulkner lived in the French Quarter, the area was going through a bohemian period, when rents were cheap because many buildings (then over a hundred years old) had fallen into disrepair. By this time, the Pontalba buildings on Jackson Square had been subdivided into apartments. Writer Sherwood Anderson (who encouraged Faulkner to write fiction) lived there and befriended Faulkner through his wife, whom the

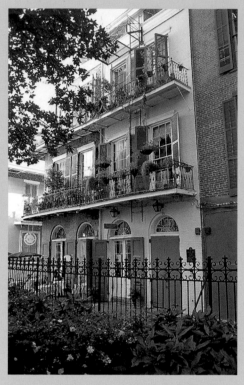

TOP: WILLIAM FAULKNER LIVED ON THE FIRST FLOOR OF THIS BUILDING IN 1925, WHEN HE WROTE HIS FIRST NOVEL *SOLDIERS' PAY*.

BELOW: THIS PLAQUE EXPLAINS THE HISTORICAL SIGNIFICANCE OF THIS HOME.

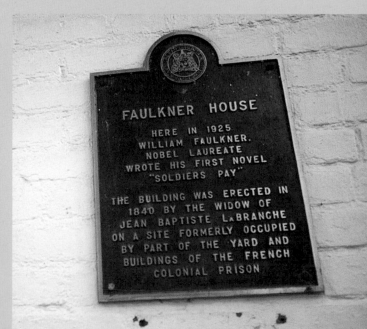

future Nobel Laureate knew from before. A boat excursion across Lake Pontchartrain that they all took together (where the heat, humidity, and mosquitoes stalked them) became the inspiration for Faulkner's second novel's setting. *Mosquitoes* parodied the cultural pretensions of certain New Orleaneans.

After getting married in 1939, Faulkner permanently moved back to Oxford, Mississippi.

In the years following, he earned a reputation for his stream-of-consciousness writing style. Literary scholars often cite the time he spent in New Orleans as pivotal to his development as a writer.

Although he never lived in New Orleans again, he visited on several occasions and was awarded the French Legion of Honor medal here in 1951.

His legacy started a flood of recognition for all Southern authors, and it continues through the PEN/Faulkner Award for Fiction, which was established with a portion of his Nobel winnings.

Today, Faulkner House Books and the headquarters of the Pirate's Alley Faulkner Society (a nonprofit organization) are located at 624 Pirate's Alley—now designated a national literary landmark. The shop is housed on the lower floor in the space Faulkner once occupied, and the owners live above in the two-room-wide, five-story house. The Pirate's Alley Faulkner Society is devoted to assisting writers and hosting an array of literary events, including one known around the world—Words&Music.

THE FAULKNER HOUSE BOOKSTORE CONTAINS FIRST EDITIONS AND WORKS OF SOUTHERN WRITERS AND CONTEMPORARIES OF FAULKNER'S FROM THE LOST GENERATION. THIS GROUP OF WRITERS, WHICH INCLUDES ERNEST HEMINGWAY AND F. SCOTT FITZGERALD, WAS LINKED IN SUBJECT MATTER TO WORLD WAR I.

ABOVE: THIS IS THE ROOM FROM WHICH WILLIAM FAULKNER WROTE *SOLDIERS' PAY*. THE PIRATE'S ALLEY FAULKNER SOCIETY FOUNDED IN HIS HONOR IS DEVOTED TO ASSISTING WRITERS AND PRODUCES EVENTS AND AN ANNUAL MEETING KNOWN AROUND THE WORLD AS WORDS & MUSIC.

FACING PAGE: ROSEMARY JAMES AND JOSEPH DESALVO, THE MODERN-DAY OWNERS OF THE HOME, LIVE ABOVE THE FAULKNER HOUSE BOOKSTORE WITH THEIR POODLE ZULI.

BAYOU ST. JOHN, ESPLANADE RIDGE, AND BEYOND

Before it was called Bayou St. John, Indians in the area knew the portage that flowed into Lake Pontchartrain as Bayouk Choupique, named in Choctaw-French after the large fish from antiquity. The bayou was an important link between the lake and the Mississippi River, where fur trappers and traders settled in the village of thatched huts on the bayou shore. New Orleans' city founder Jean-Baptiste Le Moyne de Bienville named the bayou for his patron saint, St. John. In 1701, the French established the small Fort St. John at the mouth of the bayou.

Esplanade Avenue approaches Bayou St. John and runs parallel to the water in areas. The Esplanade Ridge was land ripe for development, given its proximity to the bayou, the lake, and the French Quarter. The area first gained prominence in the late 1820s. By the 1850s, it was a Creole showplace of Classic, Greek Revival, Italianate, and Victorian homes featuring opulent interiors. The Promenade Publique on the esplanade was a posh strolling area that ran the length of Esplanade Avenue, and it is still a popular destination for local residents to walk their dogs. The area was considered quite desirable in the mid-1800s.

Unlike the Vieux Carré, this was primarily a residential neighborhood with showy and modest façades of three-bay, two-story residences with front galleries and front yards fenced in classic wrought-iron designs. The Degas House was among a distinguished row of mansions along the still-pretty avenue. The area today is home to schools, City Park, and the New Orleans Museum of Art.

FACING PAGE: THE GARDENS AT LONGUE VUE HOUSE, IN NEW ORLEANS' BAYOU ST. JOHN NEIGHBORHOOD, ARE FULL OF BREATHTAKING FOUNTAINS. THE ESTATE WAS THE HOME OF NEW ORLEANS PHILANTHROPISTS EDGAR AND EDITH STERN.

LEFT: BAYOU ST. JOHN FIRST GAINED PROMINENCE FOR RESIDENTIAL DEVELOPMENT IN THE LATE 1820S. BY THE 1850S, IT WAS A CREOLE SHOWPLACE OF CLASSIC, GREEK REVIVAL, ITALIANATE, AND VICTORIAN HOMES FEATURING OPULENT INTERIORS. IN THIS PHOTO, THE PITOT HOUSE (FAR RIGHT) WITH THE DISTINCTIVE "PIEUX" FENCE MADE OF AGED WOOD IS SHOWN. THE HOUSE WAS CONSTRUCTED IN 1799.

Pitot House Museum and Gardens

1440 Moss Street

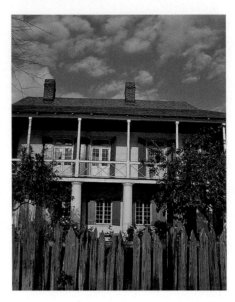

Constructed in 1799, the Pitot House that stands today in Bayou St. John is named for the fourth owner, James Pitot, the first post-colonial mayor of New Orleans. The land upon which the home is built was part of a concession granted by Jean-Baptiste Le Moyne de Bienville in 1708.

Bartholome Bosque, a merchant and ship owner originally from the island of Majorca, Spain, was the home's first owner. Because Bayou St. John was considered out in the country in the late 1700s, Bosque also had a home at 61 Chartres Street (coincidentally, the same address of Vincent Nunez, who started the fire that devastated the city in 1788). Historian Samuel Wilson writes in *The Pitot House on Bayou St. John* that Bosque borrowed ideas for the Bayou St. John house from his Chartres Street home, a French Colonial–style home built after the fire. Elements in common include the transom designs on the French doors and the floor plan featuring three rooms across the front that open into a broad gallery with two cabinets in the rear, a recessed gallery, and no center hallway.

The builder of the two hundred-foot-long plantation is unknown, but it may have been Hilaire Boutté, who completed renovations on the Bayou St. John home for a later owner, Madame Widow Vincent Rillieux, French Impressionist artist Edgar Degas' great-grandmother.

Bosque sold the place in 1800 to Joseph Reynes, who five years later sold it to Rillieux, the former Marie Tronquet. She likely added a south side porch before selling it in 1810.

By the time Pitot moved in, he had resigned his mayoral post and was a probate court judge for the territory, appointed by Governor William Charles Cole Claiborne. Pitot had fled Paris at the start of the French Revolution and high-tailed it to the Caribbean island of Santo Domingo before living in Philadelphia and Norfolk, Virginia, and then settling in New Orleans. Once here, he partnered with Daniel Clark to build one of the first cotton presses at the corner of Toulouse and Burgundy streets.

Pitot, who lived here from 1810 to 1819, may have chosen the house on the bayou for its similarity to those on Santo Domingo. Its West Indian and French Colonial influences include a wide wrap-around gallery (common in the Caribbean), French brick-between-post construction, arched casement windows, and plastered brick columns. The lack of a center hallway was common in both West Indian and French Colonial traditions, and the concept of cross-ventilating rooms by positioning doors across from each other and using high ceilings to trap warm air was prevalent in West Indian styles.

The two-story structure has no interior stairway. The second floor is accessed by an outdoor stairway. The rooms upstairs open into each other, creating an airy quality. The gallery was also used for dining and entertainment. It provides uninterrupted views of the bayou and the traditional parterre garden, which was designed to be viewed from above.

Historic plantings of cotton, herbs, indigo, sugarcane, and tobacco were cultivated along with vegetables. The cypress stockade or property fence (called *pieux debouts*) kept stray animals out of the garden.

An 1830 sketch of the house made by French naturalist Charles Alexandre Lesueur was used in the 1960 restoration of the house and still survives. Between 1830 and the 1960s, the home was owned by a number of people, including Henry Clement Albin Michel and his wife (they moved away in 1848) and Felix Ducayet, who made it a hog and poultry farm. While Ducayet owned Pitot House, he converted the roof from a double-pitched roof to a hipped one with dormer windows. It is also thought that this is when an exterior stairway located in the side gallery was added.

The house was sold at a sheriff's sale in 1857 to Paul Joseph Gleises, who sold it just a year later to Jean Louis Tissot, who lived there until 1894. The house was described in the *Daily Delta* prior to the sheriff's sale as including an overseer's house, frame stables, a coach house, a cow house, a pigeon and chicken house, and a splendid garden with hot house.

Mother Frances Xavier Cabrini, the founder of the Missionary Sisters of the Sacred Heart, obtained the house and property in 1904, following two other short-lived ownerships. The nuns used the house as their convent and eventually donated it to the Louisiana Landmarks Society. In the 1960s, the Louisiana Landmarks Society moved the Pitot House from the lot next door to make way for the modern structure that is now Cabrini High School. The society then restored the home to its original eighteenth-century form and furnished it with Louisiana and American antiques from the early 1800s. The 2005 flood following Hurricane Katrina did much damage to other buildings near the Pitot House, but this classic home was not flooded because the water simply passed underneath—proving the timeless intelligence of its design.

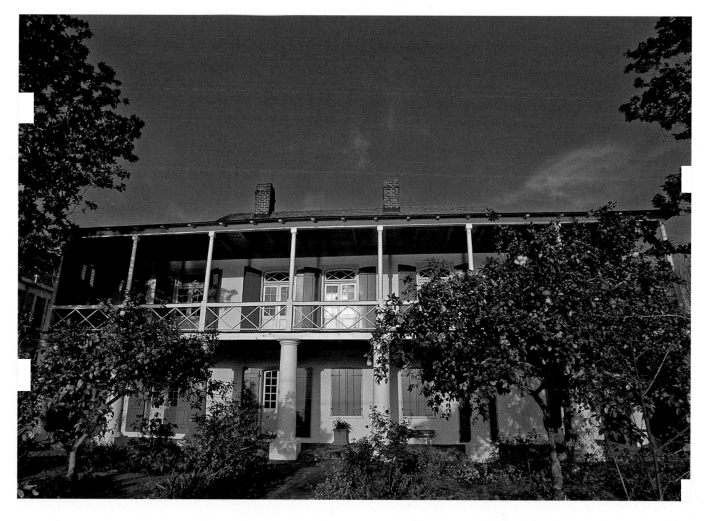

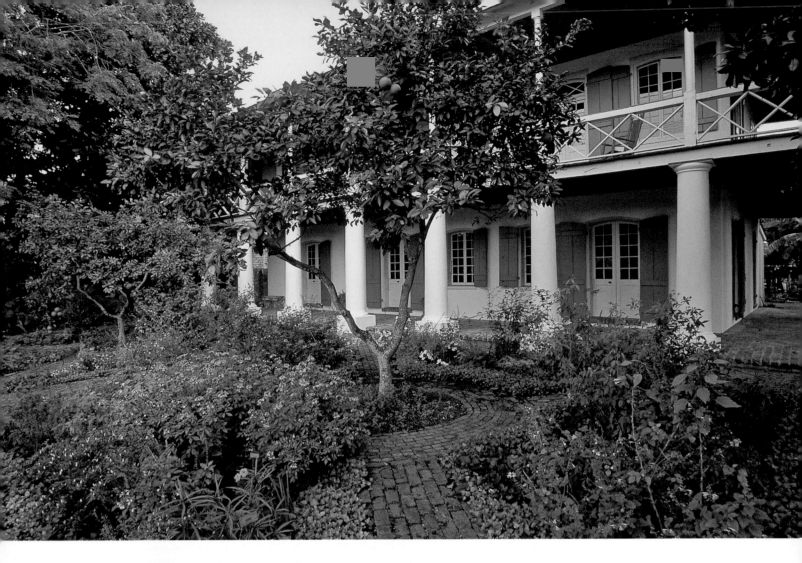

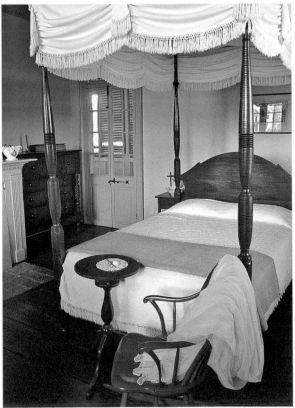

ABOVE: THE GARDEN DESIGN—
A PARTERRE, A GARDEN WITH
DIVIDED FLOWER BEDS—FEATURED
AT PITOT WAS A POPULAR FRENCH
IMPORT.

LEFT: THE HOUSE IS IN A TYPICAL
COLONIAL STYLE. IT FEATURES
THREE ROOMS IN THE FRONT THAT
OPEN INTO A BROAD GALLERY
AND UPPER ROOMS FOR PRIVATE
CHAMBERS.

FACING PAGE: FOOD WOULD HAVE
BEEN BROUGHT INTO THIS DINING
ROOM FROM THE KITCHEN, WHICH
WAS LOCATED IN A SEPARATE
BUILDING IN CASE OF FIRE.

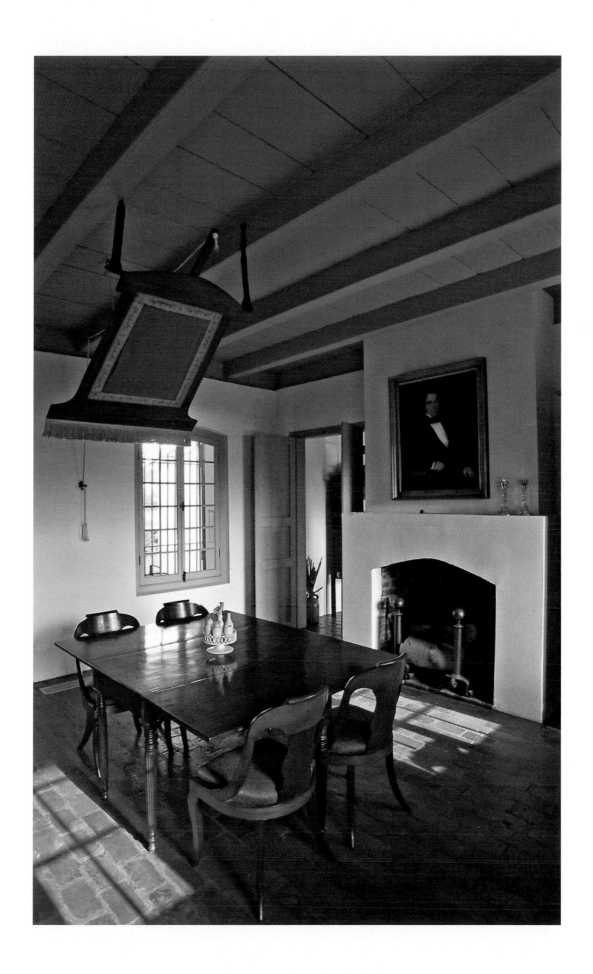

ABOVE: AS WAS COMMON IN COLONIAL OR WEST INDIES—STYLE ARCHITECTURE, THE FIRST FLOOR IN THE PITOT HOUSE WAS USED FOR STORAGE OR REMAINED OPEN AND WAS NEVER A LIVING SPACE.

FACING PAGE: THE LOUISIANA LANDMARKS SOCIETY RESTORED THE PITOT HOUSE TO ITS ORIGINAL EIGHTEENTH-CENTURY FORM AND FURNISHED IT WITH LOUISIANA AND AMERICAN ANTIQUES FROM THE EARLY 1800S.

SPREAD ON PAGES 70 & 71: NOTE THE FRENCH DOORS WITH TRANSOM WINDOWS, THE SIMPLE CEILING, AND THE WOODEN FLOORS IN THE HOME'S PARLOR ROOM. ALL OF THESE FEATURES FOLLOW IDEALS OF SIMPLICITY, A HALLMARK IN CREOLE BUILDING DESIGNS.

Edgar Degas House

In 1872, artist Edgar Degas arrived in New Orleans for a stay at a posh mansion located at 2306 Esplanade Avenue. It was away from the heart of town, in the 1873 equivalent of a New Orleans suburb called the Promenade Publique. Although he only visited the house for six months, the French artist's impression of his time in New Orleans did appear in some of his famous oil paintings and portraits and prompted the logic in naming the house at Esplanade Avenue.

The location of the home was first a parade ground for soldiers who lived in nearby barracks (which is today appropriately called Barracks Street). At the time Degas lived here, the Esplanade was the place to stroll away from the heart of town. Degas found New Orleans and its citizens fascinating during the Reconstruction.

Degas arrived in the city on All Saints' Day in 1872, at the invite of his brother, René. If he passed the St. Louis No. 3 cemetery, he would have seen crowds of people placing flowers on the graves of their loved ones in remembrance on the day after Halloween. He might not have noticed because his journey had been so long. He had taken a steamer from Paris to New York and then the train from the East Coast to New Orleans, all in anonymity, since he was not yet famous. He had not yet painted any ballet pastels or contributed to the Impressionist Movement (a term he hated). When he arrived at the Lake Ponchartrain train station, he was met by his deceased mother's brother, Uncle Michele Musson, and his family. Degas had spent some time with his cousins in Paris, where the women were sent during the Civil War. And although his mother was from New Orleans (she had died when he was young), he'd never been to the city. Now he had time to explore all that was new to him.

AT RIGHT: THE PAINTER EDGAR DEGAS RESIDED AT THIS HOUSE ON ESPLANADE DURING A SIX-MONTH VISIT TO NEW ORLEANS, DURING WHICH HE COMPLETED SEVERAL PAINTINGS THAT ARE REPRODUCED WITHIN THE HOME.

In a letter to his artist friend John Tissot, Degas wrote the following about his stay in New Orleans:

> Villas with columns in different styles, painted white, in gardens of magnolias, orange trees, banana trees, negroes in old clothes like the junk from La Belle jardinière or from Marseilles, rosy white children in black arms . . . tall funnels of the steamboats towering at the end of the main street. . . .

While staying at his uncle's home in Esplanade, Degas worked on large, richly hued, off-center compositions that featured detailed interiors of the house and portraits of his family, perhaps most poignantly, his blind sister-in-law Estelle. She posed under the staircase for the painting *Madame René Degas*, a reproduction of which today hangs in the stairwell. Sadly, her husband, Edgar's brother René, soon left her and her children. After also losing a large sum of the family's money, René Degas became the family outcast.

While Edgar Degas was staying with his family, his uncle was trying to keep up appearances by renting this grand house. Before coming here, Musson owned a home in the Garden District, but his wealth plummeted after investing in the losing side of the Civil War, and he was forced to sell. So the Esplanade Avenue house, which he rented for $300 a quarter, was what he could afford, especially given what he had paid to send the women to Paris during the war.

In subsequent letters about life on Esplanade, Degas revealed what it was like painting relatives: there were too many interruptions and they had no respect for his work. He sounded a little disgruntled and maybe a little bored. Much of his nonpainting time was spent in his uncle's office at the cotton exchange, reading the newspaper. He decided to paint there, too.

All is not what it seems in the painting entitled *A Cotton Office in New Orleans* (1873). It shows what at first appear to be workers going about their day in a professional setting of a cotton exchange. A closer look shows a few men wearing bowlers, a man in front in a formal top hat (Musson), and all of this group are wearing dark jackets. A bearded man sitting just behind the man in the top hat is reading the paper, head tilted back, legs stretched out before him. This is René. His slouch is pronounced as he leans back in his chair. The painting also has a second tier of men in the background who aren't wearing jackets and appear to be working.

Upon looking more closely at the painting, you'll notice that the men in bowlers appear not to be staying long. Indeed, Musson, Prestige & Company was on the verge of collapse when this painting was created; in fact, it closed down even before the paint was dry.

According to author Christopher Benfey in *Degas in New Orleans*, the paintings' figures in black, the cotton workers, are the same men involved in a political situation with historical significance. Musson and his cohorts, who are depicted here, were members of the Crescent City White League, the notorious Reconstruction organization that brawled with the metropolitan police in 1874 in the Battle of Liberty Place, a fight that required intervention by federal troops and left thirty people dead, after Degas was long gone.

ABOVE: THE FUTURE FRENCH IMPRESSIONIST PAINTER WAS A GUEST OF HIS UNCLE MICHEL MUSSON, WHO LIVED HERE WITH HIS FAMILY.

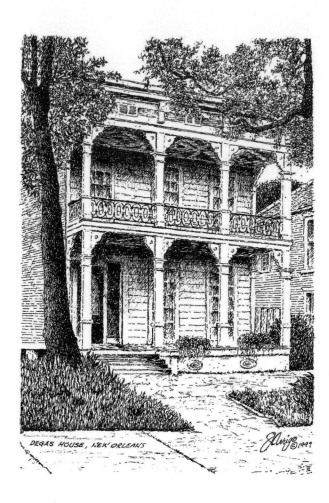

As for the painting, Degas was excited by its salability potential, but it's the underlying psychology of the painting that must have satisfied him the most. He spoke the truth through the layers of veiled reality in a wide-angled composition. The painting was featured at the Second Impressionist Exhibition in 1876 in Paris and sold two years later to a museum in the south of France.

The house on Esplanade still stands as an unlikely witness to the start of something new in art. By 1877, the Mussons were out, and the owner announced the mansion's availability in an ad in the *New Orleans Democrat* as an elegant, two-story, framed dwelling with wide halls, double-front galleries, and a landscaped yard with a carriage house, kitchen, and stable. Another description—this from the house building contract specifications—highlights the amenities as follows: ". . . two water closets or public conveniences with pipes of ten-inch diameter conducting to the privy dug several feet from the house. Marble mantels and fronts to chimneys . . . stalls for horses" (*New Orleans Architecture, Volume 5: The Esplanade Ridge*, from building contract specifications dated May 27, 1854).

The house known now as the Edgar Degas House was built by Benjamin Rodriguez, who bought the lot from Samuel Moore, a prominent property owner. At some point, the house was divided into two structures, and today both serve as side-by-side historical markers.

It is actually possible now to sleep where Degas did (so to speak) because the house is a bed-and-breakfast, a wedding-and-party venue, and a museum giving tours by appointment. Perhaps your guide might be Joan Prados, a thoughtful storyteller with her own historical tie to the house: she is the great, great-granddaughter of Estelle, the blind sister-in-law abandoned by the artist's brother, René.

A PEN-AND-INK DRAWING OF THE DEGAS HOUSE BY JOSEPH ARRIGO, DATED 1998. THIS FAÇADE SHOWS ONLY ONE SIDE OF THE HOUSE THAT WAS DIVIDED AT SOME POINT IN HISTORY. THE OTHER PART OF THE HOUSE, NOW NEXT DOOR, IS USED FOR TOUR ORIENTATIONS.

FACING PAGE: ALTHOUGH THE ARTIST HAD NOT YET CREATED HIS BALLET-THEMED WORKS (SUCH AS THIS SMALL TABLETOP SCULPTURE) AT THE TIME HE LIVED IN NEW ORLEANS, DEGAS DID PAINT THE COTTON EXCHANGE OIL (AS SEEN IN THE BACKGROUND) DURING THIS TIME.

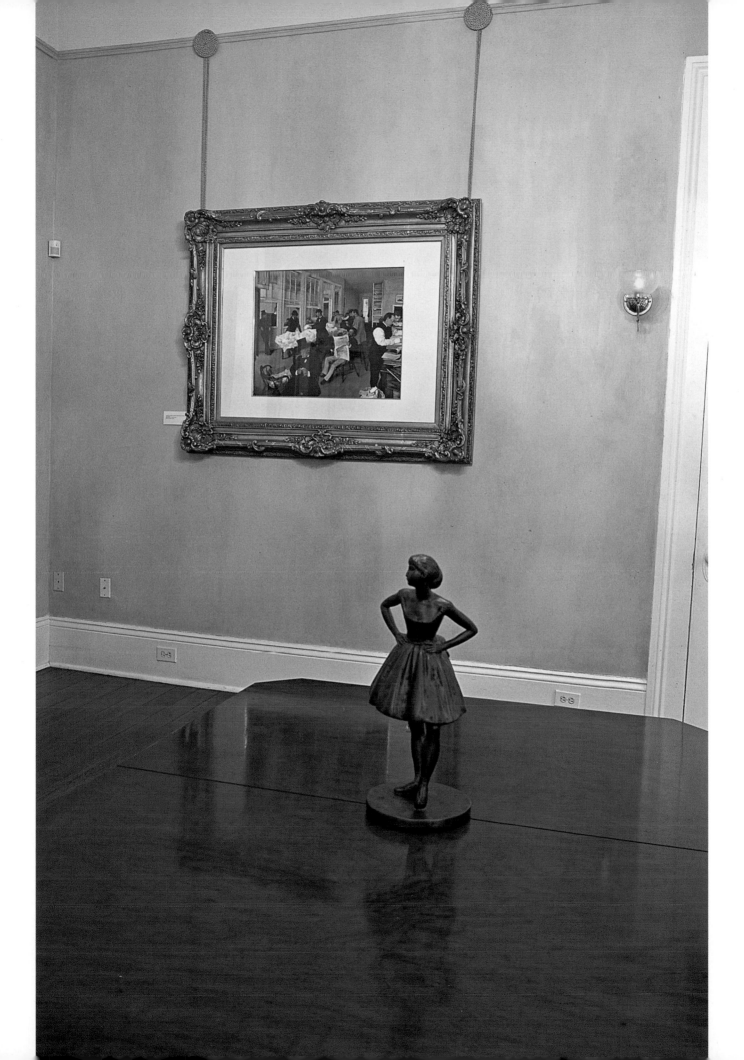

Longue Vue House and Gardens

In the 1930s on Bamboo Road, near the town of Metairie, an elaborate estate garden was being finished for a prominent philanthropic couple, Edith and Edgar Stern. However, the Sterns realized that the gardens outshined their existing 1928 house. So they hired architects William and Geoffrey Platt to construct a new custom-built home that would complement the gardens with style.

Longue Vue House, which took three years to build, was completed in 1943. It is the newest of the houses featured in

AT RIGHT: THE HOME ON THE LONGUE VUE ESTATE WAS COMPLETED IN 1942, IN A STYLE KNOWN AS GEORGIAN REGENCY OR FEDERAL WITH COLONIAL REVIVAL DETAILS.

this book, but its interior architectural features, craftsmanship, and garden filled with native Louisiana plants and flowers give it an earlier historic sensibility. The house is a three-story Classic Revival with two unusual features for any New Orleans estate: a basement and a room designed for the sole purpose of wrapping gifts.

The twenty-room mansion uniquely features four different façades that coordinate with four different themes in the gardens. The main entry is through a unique circular vestibule that has curved, sliding, wrought-iron doors. This leads to a grandiose spiral staircase that soars from the basement to a skylight. The home still has all of its original furnishings, mostly English and American antiques. It is filled with modern art and decorative art, including needlework collections, Eastern European carpets, Saffordshire transferware and creamware, and Wedgwood and Leeds pearlware. The entire estate is a rare example of fine living in the 1930s and 1940s.

The eight acres of gardens were originally designed by Ellen Biddle Shipman, a well-known landscape architect of the day who devised a masterful integration of formal and natural elements. She had a flair for water features and used them extensively in designs reminiscent of Granada, Spain's Generalife Gardens from the sixteenth century—when wealthy Christians purchased townhouses and used demolished parts to make walled gardens. The Sterns often employed Moorish craftsmen to create the gardens, adding ornate pools. Contributions to some areas of the Longue Vue gardens were also made by William Platt, an architect, and Caroline Dormon, a naturalist, author, and native-plant expert.

Edith Stern was the daughter of Julius Rosenwald, chief executive and principal shareholder of Sears, Roebuck & Company, which, under his direction, became one of the largest merchandising organizations in the world. Edgar Stern was a Harvard graduate originally from New Orleans who thrived within many different enterprises—everything from being a cotton broker to establishing and owning the first local television station (WDSU). Together, the Sterns were a stylish, powerhouse couple who gave generously of their time and money to the city of New Orleans by helping to build such great institutions as Dillard University, Flint Goodrich Hospital, and Newcomb Nursery Schools. They also developed neighborhoods like Pontchartrain Park and Gentilly Woods, once thriving middle-class neighborhoods where many successful African-Americans settled.

In separate years, each won the Loving Cup, an honor bestowed by the *Times Picayune* for the year's biggest charity contributor.

Over the years, the Sterns hosted many high-profile guests at Longue Vue, including Eleanor Roosevelt, John and Robert Kennedy, cellist Pablo Casals, and comedian Jack Benny.

The house museum and gardens have been designated a National Historic Landmark and a Historic District Commission Landmark. The house is also on the National Register of Historic Places.

After Katrina, volunteers from all over contributed money and worked to restore the devastated gardens, though the main house remained intact. Although it will take several years to restore the tremendous loss of large trees and plant life, newly replanted boxwood parterres on the Spanish Court are new visual delights.

More than just a house with gardens, Longue Vue also serves as a cultural center by offering symposia on decorative arts, architecture, gardening, and relevant issues like race relations and public education. Now Longue Vue is playing an important role in rebuilding a ravaged city by helping to revive the flood-damaged neighborhoods the Sterns once developed. Its mission is "to preserve and use the historical and artistic legacy of Longue Vue and its creators to inspire people to pursue beauty and civic responsibility in their lives." Surely, the Sterns would be proud.

A POST-KATRINA PHOTOGRAPH SHOWS THE THINNED BUT SURVIVING LIVE OAK TREES THAT FLANK AN ENTRANCE TO THE LONGUE VUE ESTATE.

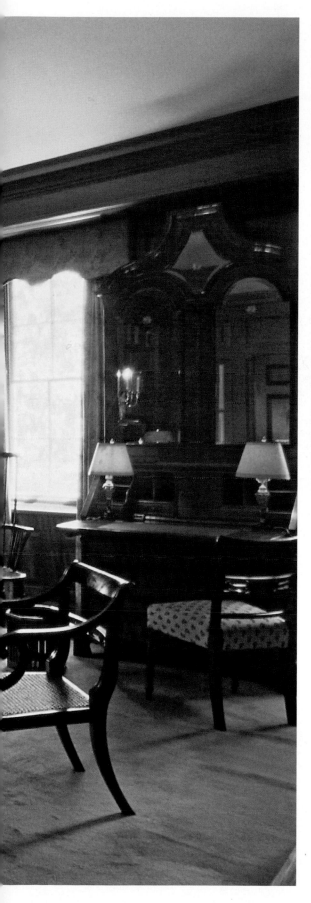

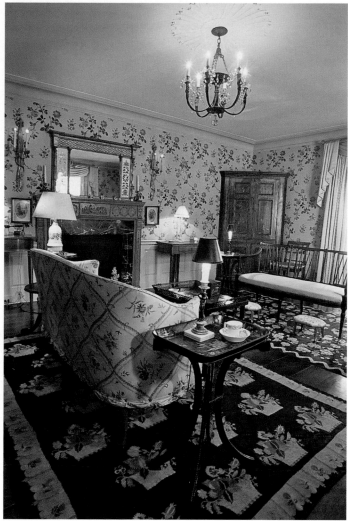

ABOVE: THIS LADIES' RECEPTION ROOM WAS FOR THE
EXCLUSIVE USE OF ENTERTAINING FEMALE VISITORS. THE
CARPETS ARE BASSARABIAN ROUMANIAN.

LEFT: THE BLUE ROOM AT LONGUE VUE WAS A FORMAL BUT
COMFORTABLE SITTING ROOM FOR OWNERS EDGAR AND
EDITH STERN. THE PANELING IS PAINTED BLUE, AND THE
MIRRORED BUREAU IS MADE OF ENGLISH WALNUT.

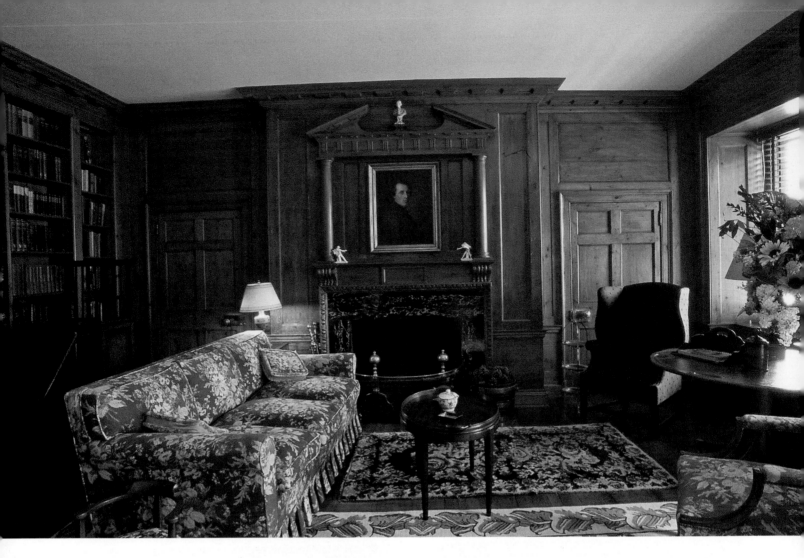

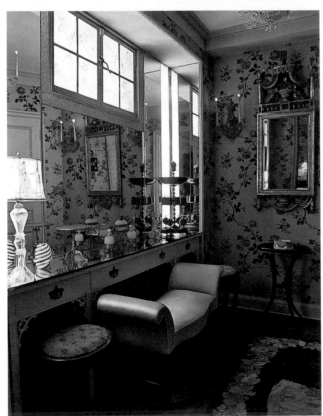

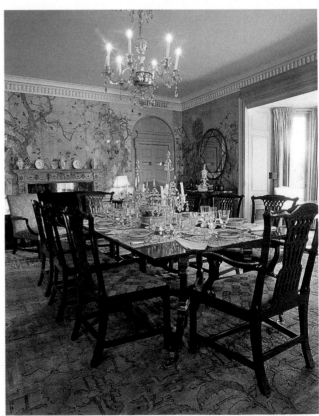

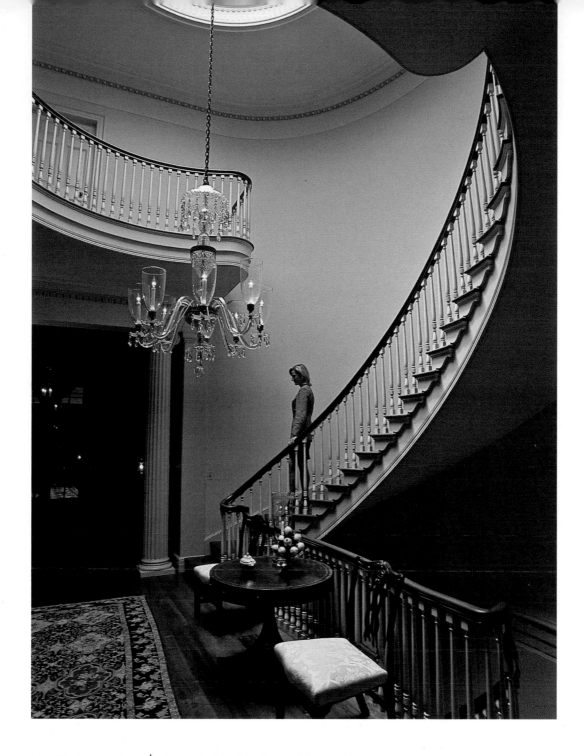

ABOVE: LONGUE VUE'S CURVED STAIRCASE LEADS TO A THIRD-FLOOR SKYLIGHT. IT IS REACHED BY A CENTER HALLWAY THAT RUNS FROM THE VESTIBULE ENTRANCE.

FACING PAGE, TOP: THE LONGUE VUE LIBRARY IS PANELED WITH EIGHTEENTH-CENTURY NORWEGIAN SPRUCE. BOTTOM LEFT: THE ROSE-MOTIF POWDER ROOM IS ADJACENT TO THE LADIES' RECEPTION ROOM, JUST OFF THE CIRCULAR VESTIBULE ENTRANCE. LONGUE VUE ATTRACTED SEVERAL CELEBRITIES FOR SOCIAL AND CIVIC FUNCTIONS IN THE 1940S. BOTTOM RIGHT: THE STERNS WERE KNOWN FOR THEIR ELABORATE DINNER PARTIES, WHICH TOOK PLACE IN THIS GEORGIAN-INSPIRED ROOM. THE ROOM WAS DESIGNED BY ELLEN BIDDLE SHIPMAN AND WILLIAM AND GEOFFREY PLATT.

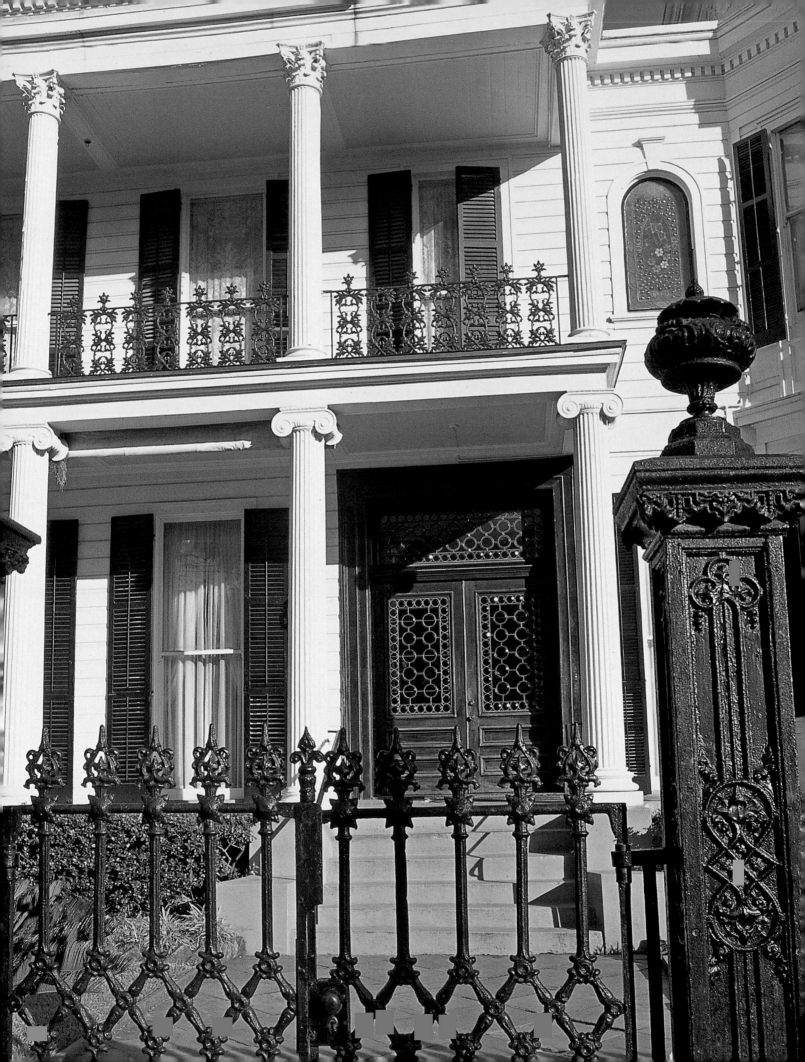

"AMERICAN" NEW ORLEANS, UPTOWN

In 1836, the Canal Street median became the boundary between the two cities that were New Orleans. Below Canal, starting with the Vieux Carré, was the original Creole city. Above Canal, in the neighborhood known as Fauburg St. Mary, was the American business district. Chartres Street on the Creole side, for example, turns into Camp Street on the American side. For seventeen years, these two sections operated almost twin cities, though they were a study in contrasts. Each side had its own churches, dry goods stores, levees, and shipping canals. And each had its own elite ruling class that resided in homes built exclusively for them. The Creoles spoke French; the Americans, English. The Creoles liked simplicity; the Americans, ostentation. These differences were reflected in the architecture found in these neighborhoods.

The Americans settled first in the Garden District, building imposing Greek Revival mansions in an area less than one square mile, which was once part of the Livaudais Plantation. But after a flood in the 1820s covered crops with river silt, the land became ripe for residential development. Americans and Europeans moved there, with many coming to the area in the early 1800s to cash in on booming Mississippi River commerce.

Farther uptown, along what is now St. Charles Avenue, was the Etienne de Bore sugar plantation, which existed until the city bought the land in 1871. The following decade it became the site of the World's Fair and Cotton Expo (1884–1885), and though part of this area is now Audubon Park, the columns from the fair still stand.

The famous St. Charles Avenue Line, a surviving historic streetcar system (dating from between 1922 and 1924), began in 1835, when it connected the New Orleans and Carrollton railroads. This is the streetcar system that still runs from the Creole sector to the American, right in front of the Columns Hotel.

LEFT: LISTED ON THE NATIONAL REGISTER OF HISTORIC PLACES, THE 1860S HOUSE IN THE GARDEN DISTRICT IS AN EXAMPLE OF SECOND EMPIRE DESIGN. THE MANSION FORMERLY OWNED BY ANNE RICE HAS BEEN CONVERTED INTO CONDOMINIUM APARTMENTS.

FACING PAGE: AN IRON GATE LEADS TO A STAINED-GLASS FRONT DOOR AT THIS GARDEN DISTRICT HOME OF THE NEW ORLEANS OPERA GUILD. IT IS LOCATED AT 2504 PRYTANIA STREET.

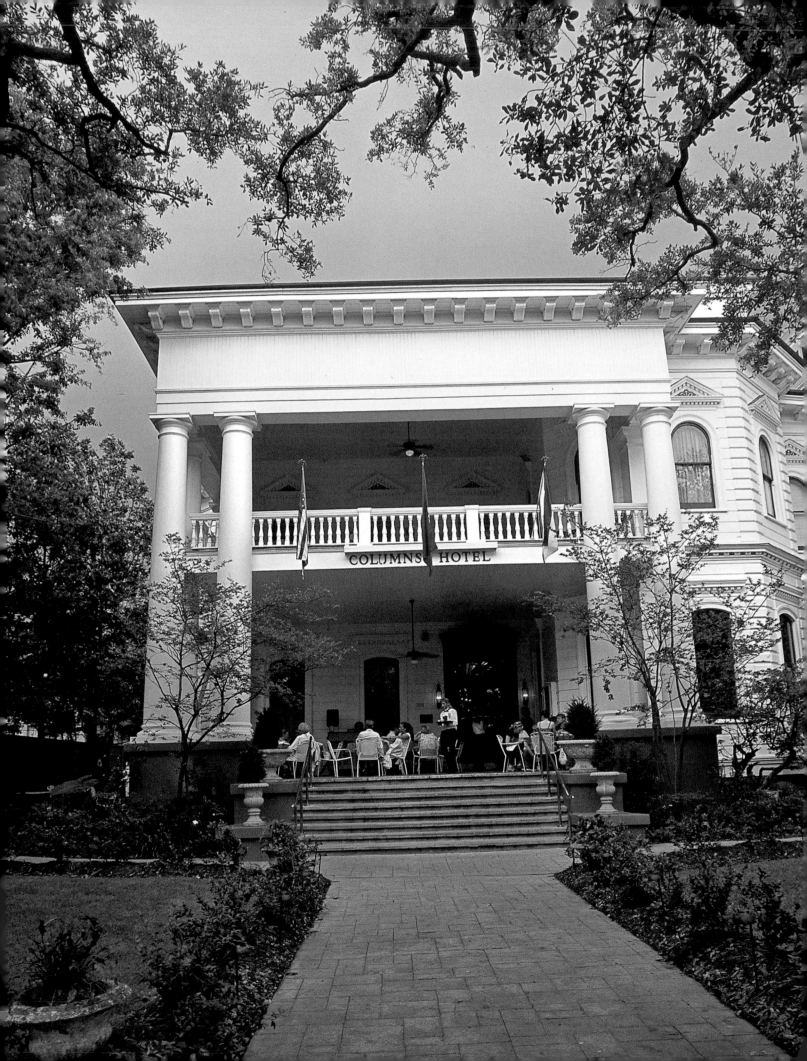

Simon Hernsheim House/Columns Hotel

Thomas Sully, architect of this 1883 Italianate villa on St. Charles Avenue, is considered one of New Orleans' most important building designers because he dominated the field at the time, and many of his buildings still stand. In 1882 Sully established himself as senior partner with Albert Toledano in the Sully & Toledano firm. This firm is credited with building numerous private homes uptown—including his own, a Queen Anne–style at 4010 St. Charles.

Other homes the firm built include one for Joseph Walker at 2503 St. Charles and a Queen Anne at 2505 St. Charles for John Morris. Commercial structures include the New Orleans National Bank (a red-brick-and-rock-faced stone, four-story building with carved heads on columns depicting allegorical figures), the Whitney National Bank, and the American Sugar Refinery Company, among others.

THE ENTRANCE HALL AND CHECK-IN DESK AT THE SIMON HERNSHEIM HOUSE/COLUMNS HOTEL. THE HOUSE IS NAMED FOR SIMON HERNSHEIM, A JEWISH CIVIC LEADER WHO OWNED HERNSHEIM BROTHERS AND COMPANY, THE LARGEST CIGAR BUSINESS IN AMERICA.

Sully was the Mississippi-born great-nephew of another Thomas Sully, the renowned English painter of American portraits who died in 1872. It's not known what effect Sully's famous relative had on the architect's sense of aesthetics, but his father, George Sully, was a competent painter and cotton broker who may have encouraged his son to draw while they waited out the Civil War.

This house, known now as the Columns Hotel, was originally built for Simon Hernsheim, a Jewish civic leader who owned Hernsheim Brothers and Company, the largest cigar business in America. The three-story home is the last remaining example of Sully's Italianate period, which lasted from 1883 to 1885. Features of this Victorian-era style in this house include overhanging eaves supported by brackets, bay windows, and a curved parapet. The first floor has a fifteen-foot ceiling, a remarkable mantelpiece, a German stained-glass chandelier, and Sully's original built-in breakfront in the main dining room, which is now the hotel's Victorian Lounge. A mahogany stairwell to the second floor showcases a square-domed, stained-glass sunburst skylight above. Originally, there were two drawing rooms (parlors), a side terrace, and a ballroom. The house features a giant two-story porch flanked by six columns.

Both Hernsheim and Sully served on New Orleans' Committee of Fifty, organized to investigate "the existence of stiletto societies in this city and to devise means to stamp them out" (according to *Vendetta: The True Story of the Largest Lynching in U.S. History*). The committee was organized to help combat an 1877 crime wave in New Orleans that coincided with the end of military occupation but was blamed on new immigrants from Sicily (some of which were connected to the Mafia). The Committee of Fifty sought to have Italian-Americans report "every bad man, every criminal, and every suspected person of your race in the city or vicinity." But tattling did not fix the problem. Tensions continued to mount, causing the Hennessy affair, an 1891 massacre by angry citizens of Sicilians falsely accused of killing the police chief.

Simon Hernsheim was also on New Orleans' sanitary and financial committees for the World's Industrial and Cotton Centennial Exposition of 1884, also known as the first New Orleans world's fair. Although the fair featured many fanciful exhibits and served brilliantly to promote the wonders of the city and the delights of the St. Charles Avenue neighborhood, it was a financial failure, losing half a million dollars of its $2.7 million cost.

In 1898, the year following the death of his wife, Hernsheim was found dead in his La Belle Creole Cigar Factory office on Magazine Street, a suicide.

THE ORIGINAL PARLOR ROOM OF THE HOME IS USED AS A DINING AREA BY THE HOTEL.

THE MAHOGANY BAR AT THE SIMON HERNSHEIM HOUSE/ COLUMNS HOTEL VICTORIAN LOUNGE. THIS ROOM WAS ONCE THE FAMILY DINING ROOM. IT FEATURES A PANELED HONDURAN MAHOGANY CEILING AND A GREEK ANTIQUITIES—INSPIRED FRESCOED FRIEZE.

PAGE 86: BRUNCH IS SERVED ON THE VERANDA AT THE SIMON HERNSHEIM HOUSE/COLUMNS HOTEL. THOMAS SULLY WAS THE ARCHITECT OF THIS 1883 ITALIANATE VILLA ON ST. CHARLES AVENUE.

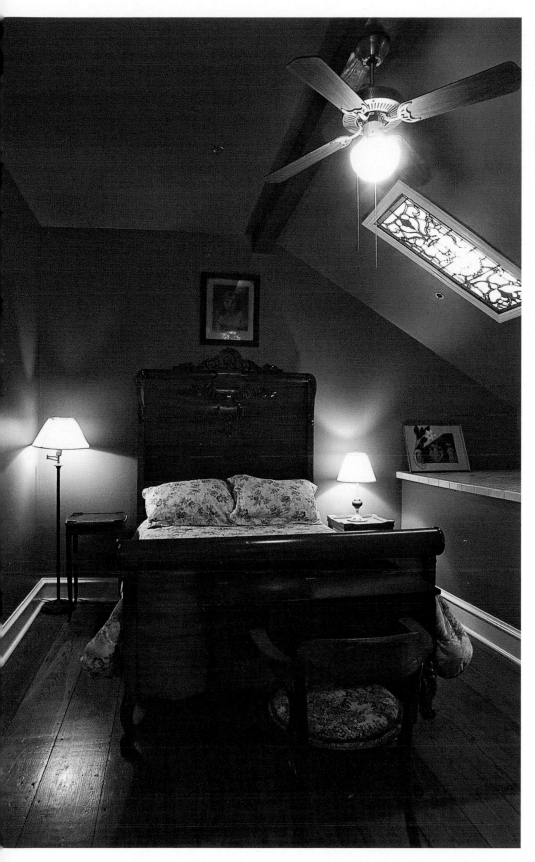

ABOVE: *PRETTY BABY* WAS A CONTROVERSIAL 1978 MOVIE FILMED HERE STARRING THEN-CHILD ACTRESS BROOKE SHIELDS. THE FILM IS BASED ON ERNEST J. BELLOCQ'S CAREER IN NEW ORLEANS.

LEFT: ALTHOUGH TURN-OF-THE-CENTURY PHOTOGRAPHER ERNEST J. BELLOCQ (1873–1949) DID NOT SHOOT THE STORYVILLE PROSTITUTE PHOTOGRAPH PORTRAITS HERE, LOUIS MALLE, THE FRENCH FILMMAKER, RE-CREATED THEM HERE. STORYVILLE WAS NEW ORLEANS' LEGALIZED RED-LIGHT DISTRICT LOCATED JUST OUTSIDE THE FRENCH QUARTER.

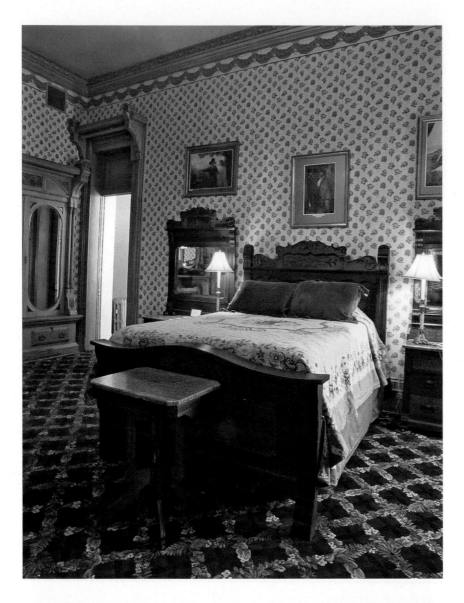

THE FELD FAMILY PURCHASED
THE HOME IN 1917 AND RAN
AN EXCLUSIVE BOARDING
HOUSE UNTIL 1953, WHEN IT
WAS SOLD AND CONVERTED
INTO A HOTEL.

LEFT: A MAHOGANY
STAIRWELL TO THE SECOND
FLOOR SHOWCASES A SQUARE-
DOMED STAINED GLASS
SUNBURST SKYLIGHT ABOVE.

FACING PAGE: A GUEST ROOM
IN THE COLUMNS HOTEL.

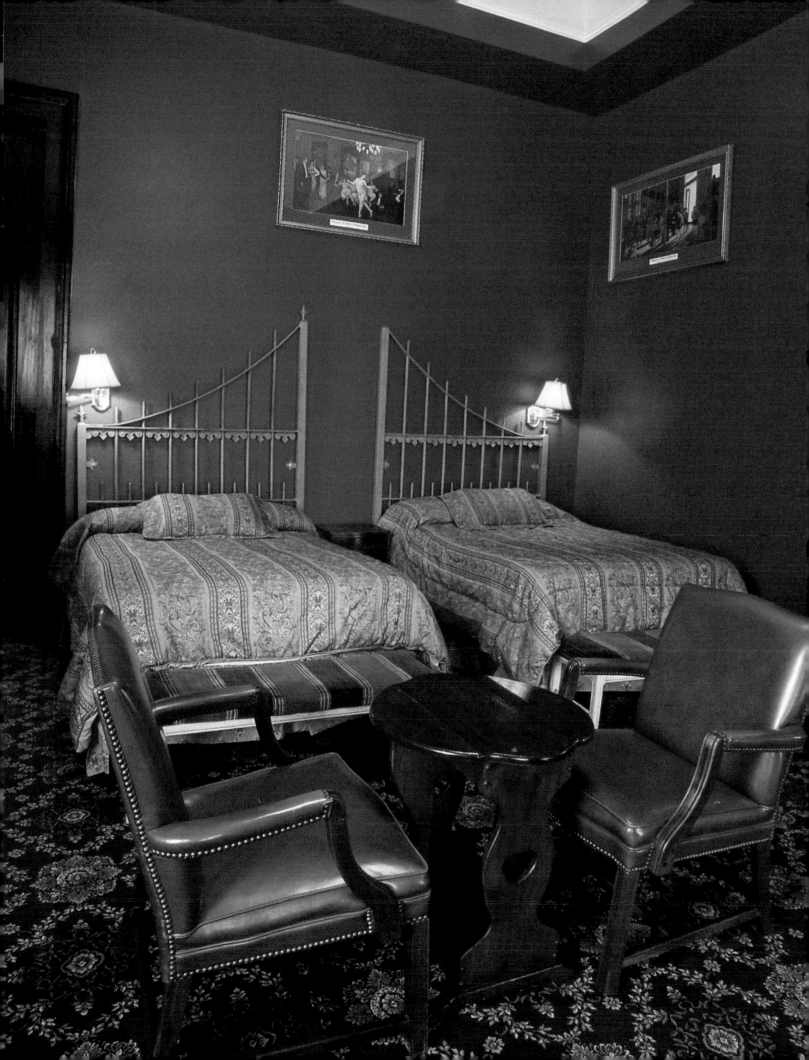

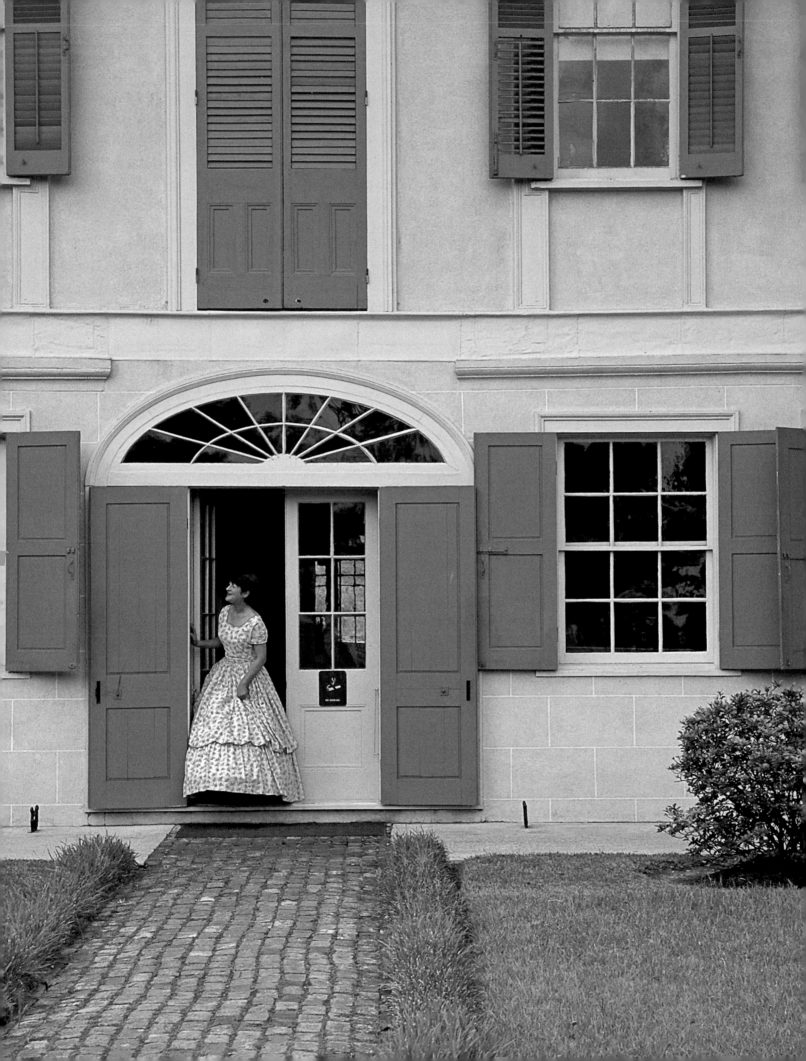

PART TWO
COUNTRY

THE RIVER ROAD

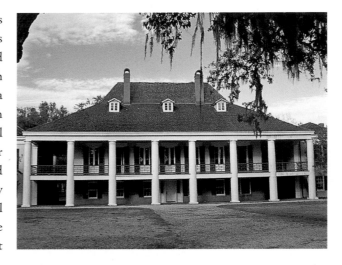

The plantations west of New Orleans were carved out in the early 1700s when farmers originally from Alsace and Lorraine, Germany, settled along both sides of the Mississippi River in an area called the *Côte des Allemands* (German Coast). They found that the drier soil upriver from New Orleans suited their needs because they could grow crops and raise cattle, which they sold in nearby New Orleans. Today there is a small town called *Des Allemands* along the *Bayou Des Allemands*, names that reflect the area's earliest European settlers.

ROBERT ANTOINE ROBIN DE LOGNY WAS THE OWNER AND FIRST OCCUPANT OF THIS ANTEBELLUM MANSION IN THE RIVER ROAD AREA. NOW KNOWN AS DESTREHAN PLANTATION, THE HOME WAS FIRST COMPLETED IN 1790, PREDATING THE LOUISIANA PURCHASE.

Sugar became the prime crop in this area before the Civil War, and expanding sugar estates along the River Road in the late 1700s and early 1800s created a great demand for West African slaves to work the far-reaching fields. French, Creole, and Anglo-American sugar barons in this area also built grinding mills and imported fancy machinery from abroad to further their industry. For themselves, they built great estates with wide porches (called galleries) facing the river so they could watch for approaching riverboats.

Although many appear to be isolated in a field, these estates' main homes were surrounded by several outbuildings, including slave cabins, overseers' homes, stables, barns, offices, *garçonnières* (bachelors' or servants' quarters), and pigeoneers—a building designed to house pigeons, similar to a dovecote. These plantation sites were places of intense industry where hundreds of workers were needed in the fields to process crops, prepare meals, clean clothing, and tend to everything a household required.

Unfortunately, as sugar production declined due to the lack of free labor after the Civil War, so did these mansions, and by the 1940s many had become white elephants in desperate need of repair. Fortunately, a restoration wave began in the 1940s and 1950s with the growth of the post–World War II economy and of automobile tourism.

FACING PAGE: SAN FRANCISCO PLANTATION WAS BUILT IN 1856 BY EDMOND BOZONIER MARMILLON. IT IS LOCATED APPROXIMATELY FORTY MINUTES FROM NEW ORLEANS, ON THE LEGENDARY RIVER ROAD IN GARYVILLE.

Destrehan Plantation

On January 12, 1787, Charles Pacquet, a free man of color, signed a contract to construct a plantation—known later as Destrehan—to be located on the banks of the Mississippi River, thirty miles upriver from New Orleans. Robert Antoine Robin de Logny, the landowner, paid him one cow, one calf, eighteen bushels of corn, and his pick of one "brute negro" (that is, a slave of his own), according to the construction contract on file at the local parish courthouse. Although this seems an odd payment today, this recorded information makes Destrehan Plantation one of the oldest documented intact houses in the Lower Mississippi Valley.

The structure took three years to build and was done with no known plan. Pacquet was directed to build a "house of sixty feet in length by thirty feet, raised ten feet on brick piers with a surrounding gallery of twelve feet, five chimneys, and the roof full over the body of the building." To follow this, Pacquet proceeded with sophisticated construction methods that utilized a heavy timber frame, French joinery, and roof-framing techniques. He laid out the home in the Spanish West Indian Creole, or simply French Creole, style. This rural type had generous galleries and a bonnet roof with a double slope extending over the open-sided galleries as protection from the elements. The roof was supported by light wooden colonettes, with the placement of the principal rooms a full story aboveground. At the time it was built, Destrehan resembled New Orleans' Madame John's Legacy and Pitot House more than it does today, with its large, plastered-brick, Doric columns in the Greek Revival style.

ABOVE RIGHT: THE PLANTATION HOUSE REPRESENTS CHANGING ARCHITECTURAL STYLES IN LOUISIANA, FROM COLONIAL AND POST-COLONIAL (THE ADDITION OF THE SEMI-DETACHED WINGS) TO THESE HUGE GREEK-REVIVAL DORIC COLUMNS OF PLASTERED BRICK.

Robert Antoine Robin de Logny, the original owner and first occupant, was a cousin of Baroness Micaela Almonester de Pontalba. He married Jeanne Dreux, a daughter of one of her friends. Unfortunately, de Logny died just two years after he moved into the home. The next inhabitants were his relatives, Celeste and Jean Noel d'Estrehan (the reason the home is now known as Destrehan). They added the plantation structure's wings to accommodate their family of fourteen children. Jean Noel d'Estrehan was one of four men assigned to the Orleans Territorial Council by Thomas Jefferson as a result of the Louisiana Purchase—the deal in which the United States bought 828,000 square miles of land from France for $15 million in 1803. From that expanse west of the Mississippi River, Louisiana and twelve other states were carved, opening the way for westward expansion. The incorporation of Louisiana transformed the way people defined what it meant to be an American. People wondered what would become of the first large population of non-naturalized Americans—Native Americans, free people of color, enslaved African and Caribbean peoples, Americans, and Francophones who made up the territory known as Orleans. This was at a time when the local ruling class thought of themselves as either French or Spanish, and their attitude toward the new American rule clashed with their deeply rooted traditions. Jefferson picked men who were respected landowners for such posts, and Destrehan had powerful connections in both the rural planter society and in New Orleans. His presence on the council gave Louisianans an immediate voice in their new system of government.

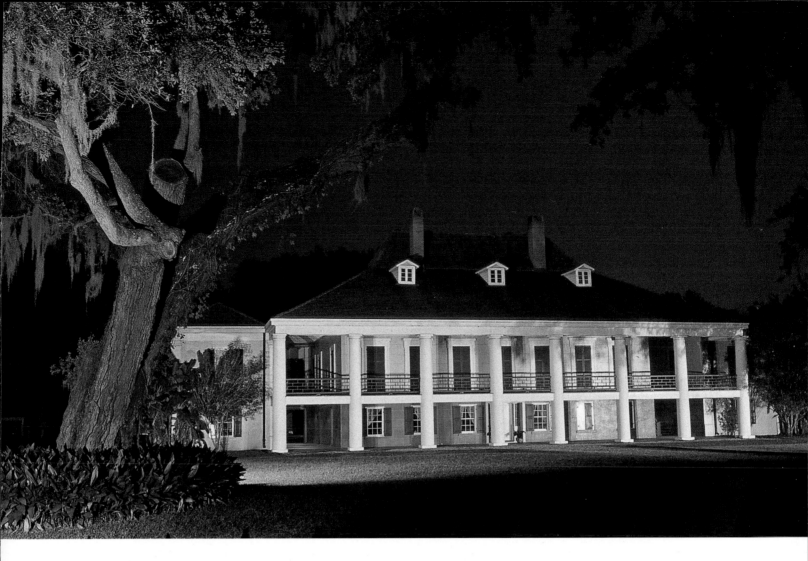

Destrehan later held a seat in the state senate from 1812 to 1817. When Jean Noel died in 1834, the house was purchased by his youngest daughter and her husband, a Scottish millionaire thirty years her senior named Stephen Henderson. Henderson's controversial will stipulated that slaves be freed upon his death, but this decree was not acted upon. The next owner, Judge Pierre Rost, married Louise Odile Destrehan. They purchased Destrehan Plantation following Henderson's death.

In the 1830s, the home's doors and windows were replaced, and the Doric columns were added, transforming the house into a Greek Revival style. The back gallery was enclosed to make an entry foyer. At the beginning of the Civil War, Rost was appointed as one of the Confederate commissioners to Spain, remaining there until the end of the war. While he was away, the Union Army seized the home, and the Freedman's Bureau installed 700 newly freed slaves and their families there. After the war, Rost was able to get his house back, and he devoted his energies to the restoration of his property.

In 1877, Rost's son bought it and lived there until it was sold in 1910 to a petroleum company and an oil refinery, each using the house for different purposes. From 1958 to 1971, the house and property were vandalized and neglected until the River Road Historical Society rescued and restored them. Today the plantation displays a portrait of Lydia Rost (a daughter of Judge Rost), who died in 1853 from yellow fever, and Jefferson's original letter to Destrehan, appointing him to the territorial council.

ROBERT ANTOINE ROBIN DE LOGNY CONTRACTED WITH A FREE MAN OF COLOR NAMED CHARLES PACQUET TO BUILD THE FRENCH CREOLE HOUSE AND OUTBUILDINGS AT DESTREHAN. FRENCH CREOLE ARCHITECTURE BEGAN APPEARING IN THE FRENCH COLONIAL PERIOD (1699–1762), BUT THE TRADITION CONTINUED INTO THE 1800S.

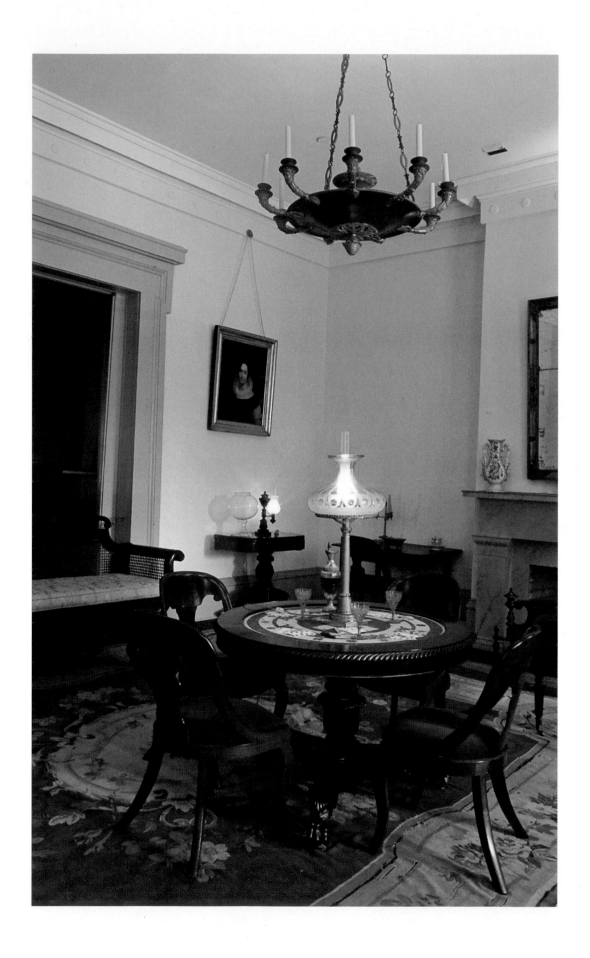

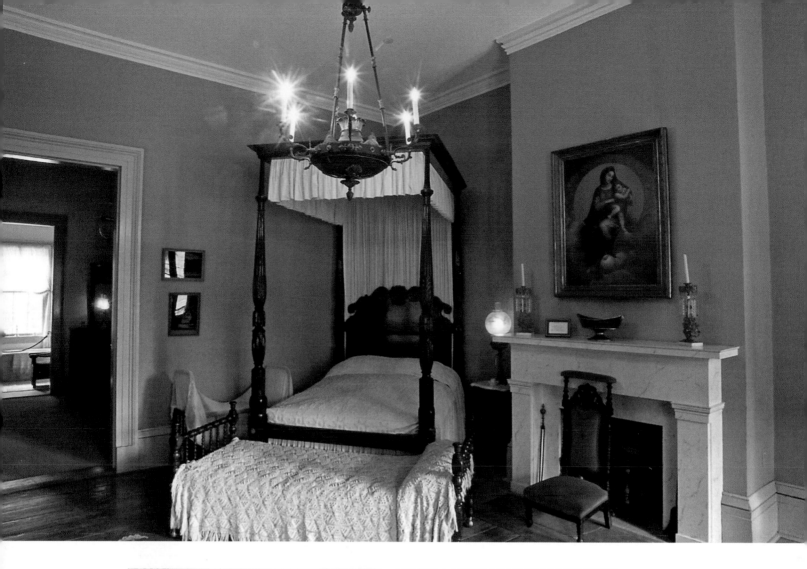

ABOVE: A DESTREHAN BEDROOM WITH
ANTIQUE BED AND FURNISHINGS.

LEFT: JEAN NOEL DESTREHAN, THE
ONE-TIME OWNER FOR WHOM THE HOUSE IS
NAMED, WAS ONE OF FOUR MEN ASSIGNED
TO THE ORLEANS TERRITORIAL COUNCIL BY
THOMAS JEFFERSON AS A RESULT OF THE
LOUISIANA PURCHASE.

FACING PAGE: THE PARLOR ROOM WAS
WHERE FAMILY MEMBERS PLAYED GAMES
AND ENTERTAINED VISITORS. ALTHOUGH
THIS FURNITURE IS NOT ORIGINAL TO THE
HOUSE, A BATHTUB GIVEN AS A GIFT BY
NAPOLEON REMAINS.

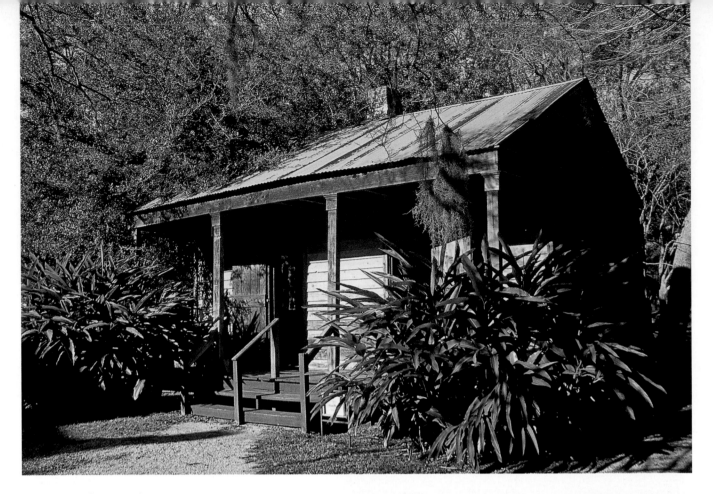

ABOVE: A SLAVE QUARTERS OUTBUILDING AT
DESTREHAN. THIS STRUCTURE IS THOUGHT TO
DATE FROM THE CIVIL WAR AND IS ONE OF TWO
OUTBUILDINGS INTENDED FOR WORKERS.

RIGHT: THE DESTREHAN PLANTATION
VEGETABLE GARDEN IS IN CLOSE PROXIMITY
TO THE MAIN HOUSE. THE PLANTATION WAS
ALSO AN IMPORTANT SUGAR PRODUCER IN THE
NINETEENTH CENTURY.

FACING PAGE:

TOP: THE DESTREHAN PLANTATION LAUNDRY
ROOM SHOWS THE METHODS FOR CLEANING
CLOTHING DURING THE 1800S. DESTREHAN
IS OWNED BY THE NONPROFIT RIVER ROAD
HISTORICAL SOCIETY, FORMED BY COMMUNITY
MEMBERS WHO WERE DETERMINED TO RESCUE
THE HOUSE FROM DETERIORATION.

BOTTOM: DESTREHAN PLANTATION GUIDE
MAMIE MCMILLION DEMONSTRATES HOW INDIGO
DYE WAS MADE IN A POT OVER A FIRE. THE
TOXIC DYE PROVED FATAL FOR SOME SLAVES.

Indigo

In 1790, the main crop planted and grown on the grounds of Destrehan was indigo. The indigo plant produces a distinctive violet-blue dye used to color yarn or threads, which are then woven into fabrics. The dye has been around for centuries and was first used in India. By the late 1700s, Europe and the New World used the dye to color military uniforms and other garments. Acres of the species ranging in height from two to six feet were grown at Destrehan. The crop did not require much labor, except during July, August, and September, when the plants were cut and fermented, and the dye extracted.

This dye is not soluble in water and must undergo a chemical change or fermentation before it can be used. First, the whole crop is bunched and tied and then put into a very large tub with water, then covered over with wood pressers. The fermented liquid is then drawn off into another tub and agitated by paddles, which form a mash. The mash is derived from a skillful maceration whereby the grain sinks to the bottom of the tub en masse and the remaining liquor is drawn off into a third tub to derive any indigo that has settled to the bottom. The sediment that remains is the indigo; this is dried, then formed into small, dark blue pieces, ready for use or export.

Since the process described required several chemical manipulations, and because of indigo's toxic nature, many slave workers who paddled the mash received skin injuries. In fact, some slaves from Destrehan Plantation died when these toxins reached the bloodstream. Eventually, methods evolved to eliminate this hazard, but that didn't happen in this geographical region.

In 1792, Destrehan Plantation owner Robert Antoine Robin de Logny lost the conract to sell indigo to England, and by then a species of insect had already ravaged much of his crop. His "Plan B," planting sugarcane, worked out much better. Eventually, sugarcane proved to be much more profitable.

Although sugarcane was first brought to the colony in 1751 from Santo Domingo and planted by the Jesuits on their New Orleans–area plantation, the cane was used only for chewing purposes at that time. In 1791, a Spaniard named Mendez figured out how to make sugar from the cane, but he didn't commercialize the process. That happened first in the territory in 1794. And by the time de Logny's son-in-law Jean Noel Destrehan bought the plantation in 1800, he had expanded the holdings to approximately 6,000 acres, part of that for cultivating sugarcane. His brother-in-law, Etienne de Bore, first granulated sugar on a commercial scale in 1795. His plantation was located approximately six miles uptown from New Orleans, in what is now Audubon Park.

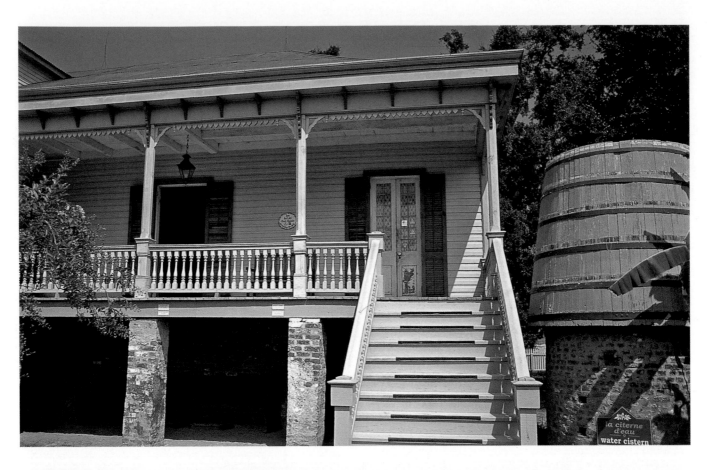

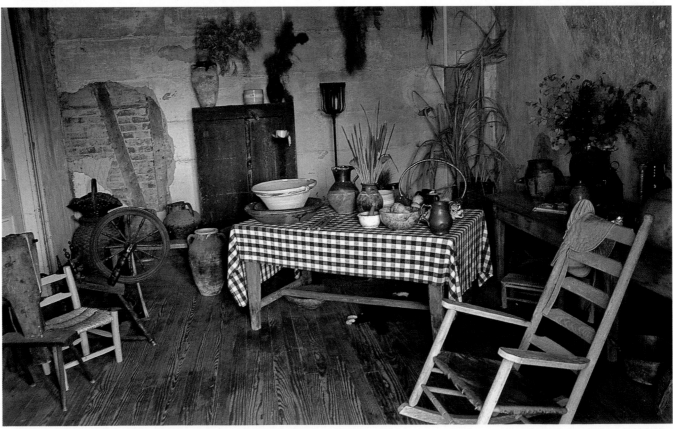

Laura Plantation

2247 HIGHWAY 18
VACHERIE, LOUISIANA

Guillaume Gilles DuParc was my grandmother's father; my g'grandfather was Le General Guillaume DuParc. He came over along with Generals Rochambeau and Lafayette to offer their services to this country. DuParc joined L'Admiral DuGrasse's Navy at the order of his father. He came over with the French in the eighteenth century with De Grasse to fight in the war.

— Memories of the Old Plantation Home

Laura Locoul Gore, for whom Laura Plantation is named, came from a Creole family with deep roots in Louisiana's plantation country. Her great-grandfather Guillaume Gilles DuParc settled the family plantation about fifty-four miles north of New Orleans along the Mississippi River in the early 1800s. Laura was among the third generation of family members to live on the land, and in the mid-1930s, she chronicled her family's history and experiences in a memoir, *Memories of the Old Plantation Home*. Now published as a book, the content paints a picture of the plantation as a business home, rather than an opulent showplace for ballroom parties. It also shows how life in Louisiana was far more like life in the Caribbean than in the rest of the South. But perhaps most intriguingly, it shows the complex relationships within the household among the family and its slaves.

CONSTRUCTED IN 1820, THE MAIN HOUSE HAS A RAISED, BRICK BASEMENT STORY AND A BRIQUETTE-ENTRE-POTEAUX (BRICK BETWEEN POSTS) UPPER FLOOR.

Of all the plantations in the New Orleans area, Laura Plantation tells the story of slavery best. On a tour, visitors learn that Laura's grandmother seemed not to recognize or care about the humanity of the slave families, much to Laura's mother's horror. The grandmother, Elizabeth, had a slave known as Pa Phillipe, who was branded on his forehead like cattle. When Laura was seven years old, she asked him about it, and he said, "This is where they branded me when I used to run away." The little girl was shocked and did not understand what her grandmother meant when she used the term "Negro spoilers."

Elizabeth tried to break up a family and sell Anna, an enslaved woman with a small child. Laura writes, "Mother called for Father hastily to come to her, telling him: 'I believe your mother is selling Anna and separating her from her child. Wouldn't that be the same as if our baby was taken from us?'" So Laura's father bought back Anna, enraging his mother. In the end, Anna became a household servant who cared for Laura as a young girl and later even attended her wedding.

The incident with Anna happened in 1862, and by then the Civil War was underway. Laura's father went to fight on the front and was unable to return to the house before the enemy arrived. Laura writes, "Mother escaped with me in a buggy wrapped up with a tablecloth and the silverware. As was feared, the place was shelled, four cannonballs hitting the big house."

FACING PAGE: TOP: GUILLAUME DUPARC SETTLED THE FAMILY PLANTATION NOW KNOWN AS LAURA PLANTATION ABOUT FIFTY-FOUR MILES NORTH OF NEW ORLEANS ALONG THE MISSISSIPPI RIVER IN THE EARLY 1800S. BOTTOM: THIS LAURA PLANTATION KITCHEN SCENE SHOWS A SLEEPING CAT UNDER THE DINING TABLE. LAURA IS NAMED FOR LAURA LOCOUL GORE, THE GREAT-GRANDDAUGHTER OF GUILLAUME DUPARC.

But the house survived, and the plantation continued to operate after the war by using workers who still wished to be there.

Before Laura's family lived here, the plantation site was a Colapissa Indian village known as Tabiscania, or "long river view." It became the property of André Neau in 1755 in a French royal land grant. Laura's great-grandfather, Guillaume DuParc, a French veteran of the American Revolution, became the owner after Thomas Jefferson bestowed the land to him in 1805. DuParc and seventeen enslaved West Africans from French Senegal and the Senegambian basin cleared approximately 12,000 acres and planted indigo and pecans and, later, cotton and rice. The West Africans were chosen because of their skills in building, cooking, and cultivating, which they had taught to their offspring. They also shared their folktales of Compain Lapin (also known as Br'er Rabbit) while living here more than 125 years ago.

The original house, which still stands, was constructed in 1820. It has a raised, brick basement and a *briquette-entre-poteaux* (brick-between-posts) upper floor. The house features Federal-style interior woodwork and a Norman truss roof system that resembles a ship's hull in that it is supported by the pressure of the two sides as they push together. The timber frame is then held together with pegs. This system, called the "scribe rule method," uses matching pieces of timber that are cut and numbered, then locked in with correspondingly numbered pegs, which create a peg-lock system.

An electrical fire in 2004 caused much damage to the home, but it did not stop historical tours of the property, where six slave quarters and a rare collection of small cypress outbuildings help illustrate the development of a sugarcane plantation from the antebellum period well into the twentieth century.

The house has now been completely restored from the fire, and the 17,000-square-foot structure was refurbished using more than 35,000 feet of centuries-old cypress and pine, much of it donated by John Cummings of Whitney Plantation. The house was put back together like one big jigsaw puzzle, using the scribe rule method as described. Laura would be proud.

THIS PLANTATION HOUSE
MUSEUM EXPERTLY INTERPRETS
THE INSTITUTION OF SLAVERY
THROUGH THE STORIES OF
THOSE WHO RESIDED AND
WORKED HERE.

THE NETTING USED IN THIS LAURA PLANTATION BEDROOM WAS NECESSITATED BY THE
MOSQUITO POPULATION THAT CONTINUES TO THRIVE IN THESE AREAS.

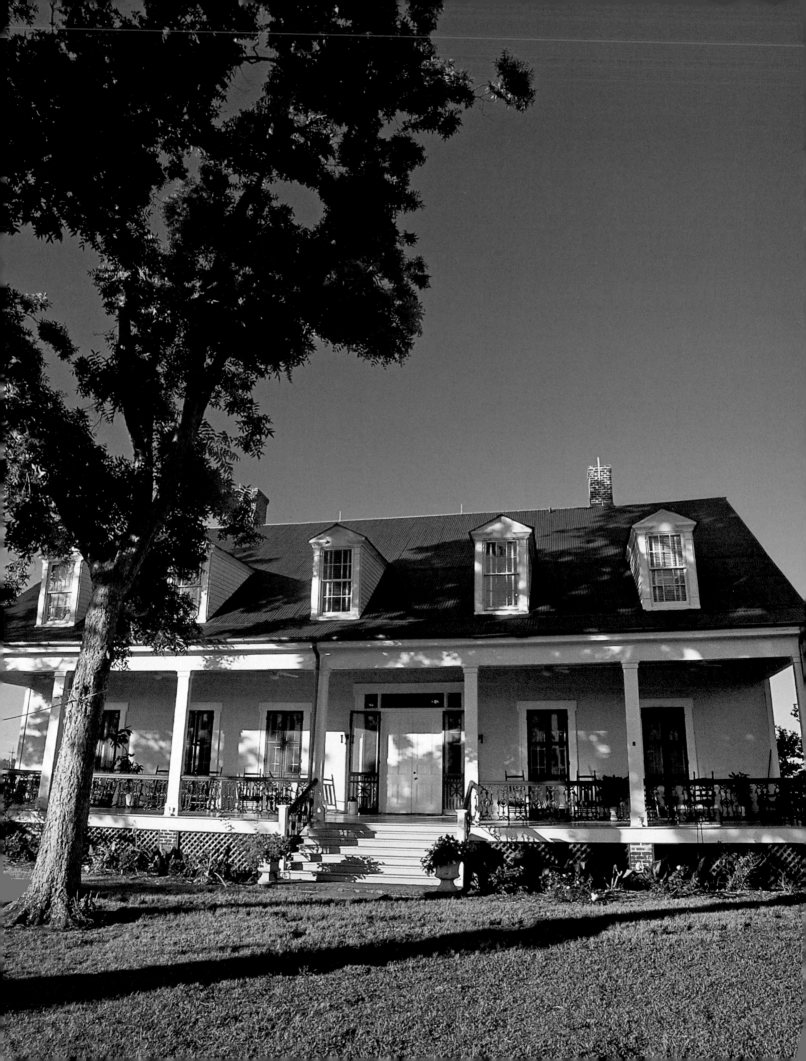

DOWNRIVER
THE DEEP DELTA

"Downriver," where the world's third-longest river system's mouth meets the Gulf of Mexico, has always been a crucial juncture for both the Mississippi River area and the world in terms of establishing colonies, trading goods, and conducting military strategy. This meeting of major waterways about fifty miles below present-day New Orleans was first a major artery for native inhabitants, the Tchefuncte, and then later early French settlers.

This also was pirate country. Passing here first before reaching points north could be treacherous for unsuspecting cargo crews; for this reason it was guarded carefully by people throughout history. In 1699, Jean-Baptiste Le Moyne, Sieur de Bienville, tricked English captains into believing that the French already had a fort and settlements north of the Deep Delta. As a result, British ships turned around before going too far upriver, in an area now long known as English Turn.

The Deep Delta has always been abundant with freshwater fish and oysters. Shrimp taken from the briny delta waters have added to the seafood menu that is a staple of the diets of the people here. The subtropical region's river land is thought to have the richest soil in the American South, but settlers have faced a host of environmental problems, including floods, physical isolation, and insect pests. Despite these obstacles, the swamplands of the lower Mississippi River Valley have been largely transformed over the years into farms growing indigo, rice, sugarcane, oranges (introduced in 1750), and even tomatoes.

ABOVE: WOODLAND FEATURES ORIGINAL FIREPLACES AND A MAHOGANY STAIRWAY.

FACING PAGE: WOODLAND PLANTATION, DOWNRIVER FROM NEW ORLEANS, IS MOST WELL KNOWN AS THE HOME IN THE CURRIER & IVES SKETCH FEATURED ON THE LABEL OF SOUTHERN COMFORT BOURBON.

One of the first plantations here, Magnolia Plantation, was built by Captain William Johnson and his partner, George Bradish, who were pirating sea captains who had come from Nova Scotia in the 1780s. They worked for a well-connected river pilot named Juan Ronquillo, the captain of the ship that brought the first Spanish governor, Don Antonio Ulloa, to Louisiana. Together, Ronquillo, Johnson, and Bradish owned land in the Buras settlement, which later became part of Plaquemines Parish.

Plaquemines Parish was organized March 31, 1807, as one of Louisiana's original nineteen parishes, and it had its start as an old military post. The name, Plaquemines, comes from an Indian word, *piakimin*, meaning persimmon, and it was given to the region because it was full of persimmon trees surrounding the banks of the Mississippi. Today, the area where the Mississippi meets the Gulf is an operational center for the offshore oil and gas industry. At one time, more than sixty plantations graced the ninety miles of the river that leads south from New Orleans to the Gulf of Mexico, but because of hurricanes, fires, floods, and crop failures, only one remains—Woodland Plantation.

Woodland Plantation and Spirits Hall

After Juan Ronquillo sold his boat access rights near the entry to the Gulf of Mexico's Southeast Pass to Captains Johnson and Bradish, they made a fortune from the fees they collected from riverboat captains who wanted to travel through here. With some of the money, they decided in 1793—prior to the Louisiana Purchase—to build a large home known as Magnolia along the river, about four miles south of where Woodland Plantation now stands. Both families lived at Magnolia for approximately forty years until William Johnson built the property known today as Woodland. On it, he and his four sons established a thriving sugarcane plantation by using one of the most modern mills of its time.

The main home at Woodland is a two-story Creole and Greek Revival structure with a wide front-facing gallery, slim columned supports, five dormer windows within a slanted roof, and twin chimneys at both ends. The floor plan is the Creole type, with no center hall and a total of thirteen rooms—nine of which have been transformed into guest bedrooms. Inside, the original fireplaces remain intact, as does a mahogany rail lining the stairway. The fifty acres of grounds (originally twenty-one) contain a tin-roofed slave cabin, built in 1840, and the overseer's house, which is in repair. Ruins of the old brick sugar mill are partially covered by vegetation.

While running the plantation, Captain Johnson still stayed busy on the water. He often traveled to nearby Grand Bayou from Woodland to pick up slaves from Jean Lafitte, the pirate turned hero after the Battle of New Orleans. Lafitte raided slave ships in the Gulf of Mexico and brought their "cargo" up to Grand Bayou. Then Captain Johnson would house the slaves on his property until they were sold.

ABOVE RIGHT: WOODLAND PLANTATION'S SPIRITS HALL, PICTURED HERE, IS A RELOCATED, RENOVATED, AND DECONSECRATED CHURCH THAT WAS MOVED TO THE GROUNDS. IT IS NOW USED AS A DINING HALL.

After Johnson retired in 1826, the plantation went to his eldest son, George Washington Johnson, who ran the 2,100-acre plantation until he died in 1856. The captain had willed it to the younger brother, Bradish, but because he was too busy traveling between his New Orleans estate (now the McGehee School at 2343 Prytania) and a townhouse in New York, the plantation did not appeal to him. Although he was mostly an absentee landlord, Bradish did use his Yankee connections to help Woodland survive the Civil War. He was able to arrange for a U.S. provost to set up a headquarters at the site.

When Bradish Johnson died in 1897, the property was sold to Theodore Wilkinson for use as a hunting lodge. The location of the Mississippi Delta at the end of the Mississippi Flyway provides winter habitat for more than one million ducks and geese and additional millions of waterfowl during their annual migrations to and from their wintering habitat in Central America.

The Wilkinson heirs held the property until 1997 when the current owner purchased and renovated Woodland to be a bed and breakfast, attracting tourists and sportsmen. Although no original

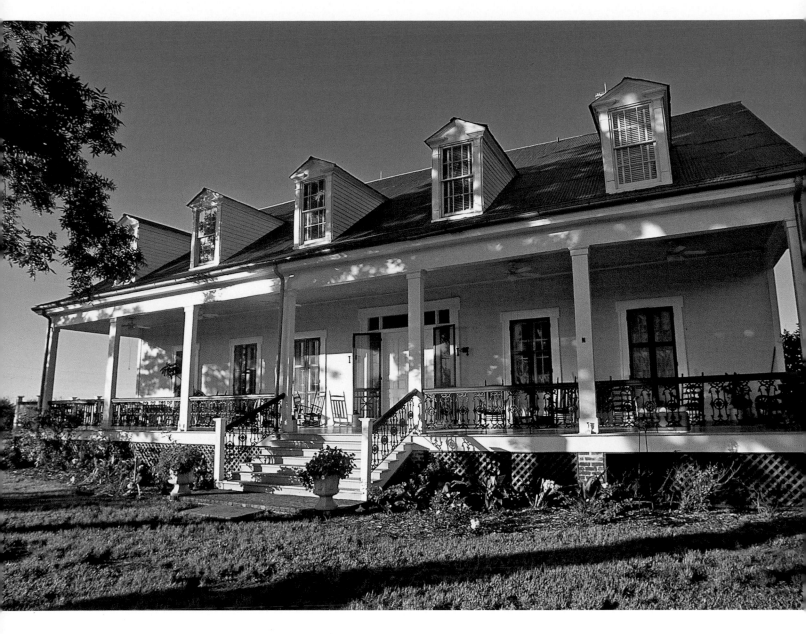

furnishings remained at the time of the 1997 sale, the new owners did discover a hand-painted border paper in a bedroom.

Another historic building—Spirits Hall, circa 1883—was moved to the site in 1998. The former St. Patrick's Catholic Church was moved from Homeplace, Louisiana, fourteen miles south of Woodland, and was restored and deconsecrated. Today, the old church is a stunning dining hall with Brazilian cherrywood floors. Spirits Hall is used by visitors after their tour and by the bed-and-breakfast guests, who can relax and socialize here during their stay. The church has a vaulted-barrel ceiling, Gothic, stained-glass windows, and a mahogany bar with arched panels, but the pews and altar are gone. The Woodland Plantation house is most well-known as the home in the Currier & Ives sketch featured on the label of Southern Comfort bourbon. Woodland is registered in the National Register of Historic Places.

THE RAISED CREOLE AND GREEK REVIVAL TWO-STORY HOME AT WOODLAND PLANTATION FEATURES A WIDE FRONT-FACING GALLERY, SLIM COLUMNED SUPPORTS, FIVE DORMER WINDOWS WITHIN A SLANTED ROOF, AND TWIN CHIMNEYS AT BOTH ENDS.

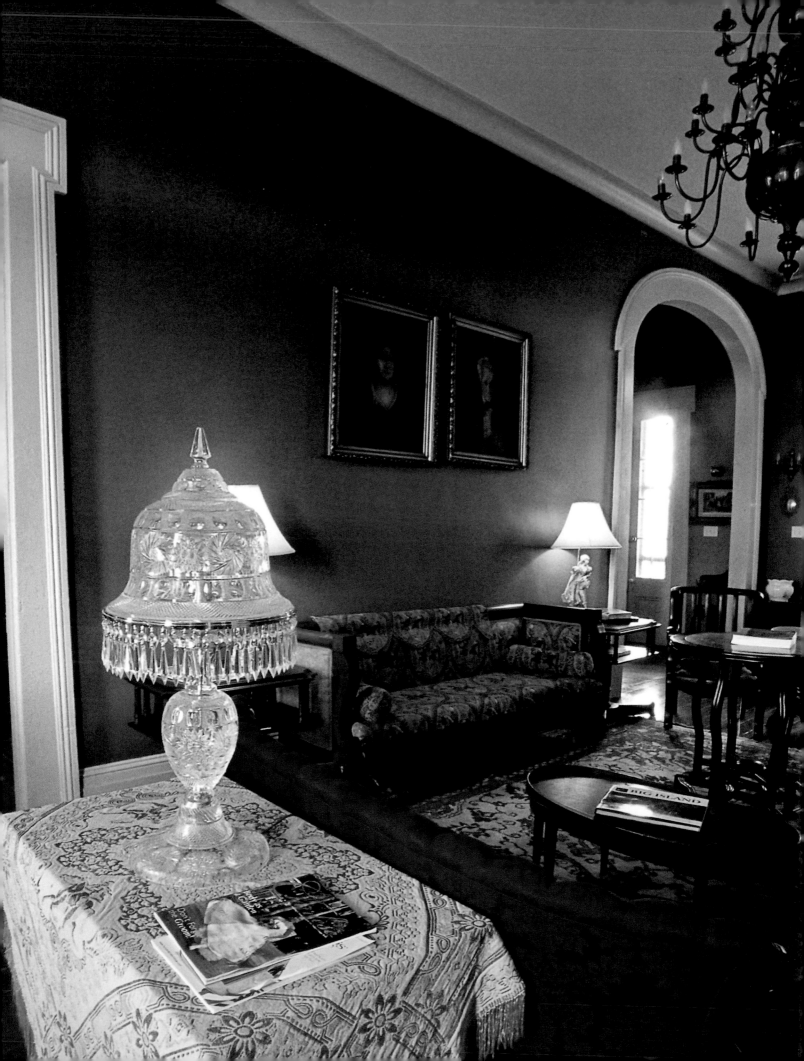

NOW OPERATING AS A BED AND BREAKFAST AND HOUSE MUSEUM, WOODLAND IS POPULAR WITH GUESTS BECAUSE OF ITS PROXIMITY TO THE MOUTH OF THE MISSISSIPPI RIVER, A FERTILE AREA FOR FISHING AND HUNTING.

FACING PAGE: THE FLOOR PLAN AT WOODLAND IS THE CREOLE TYPE, WITH NO CENTER HALL AND A TOTAL OF THIRTEEN ROOMS, INCLUDING THIS PARLOR.

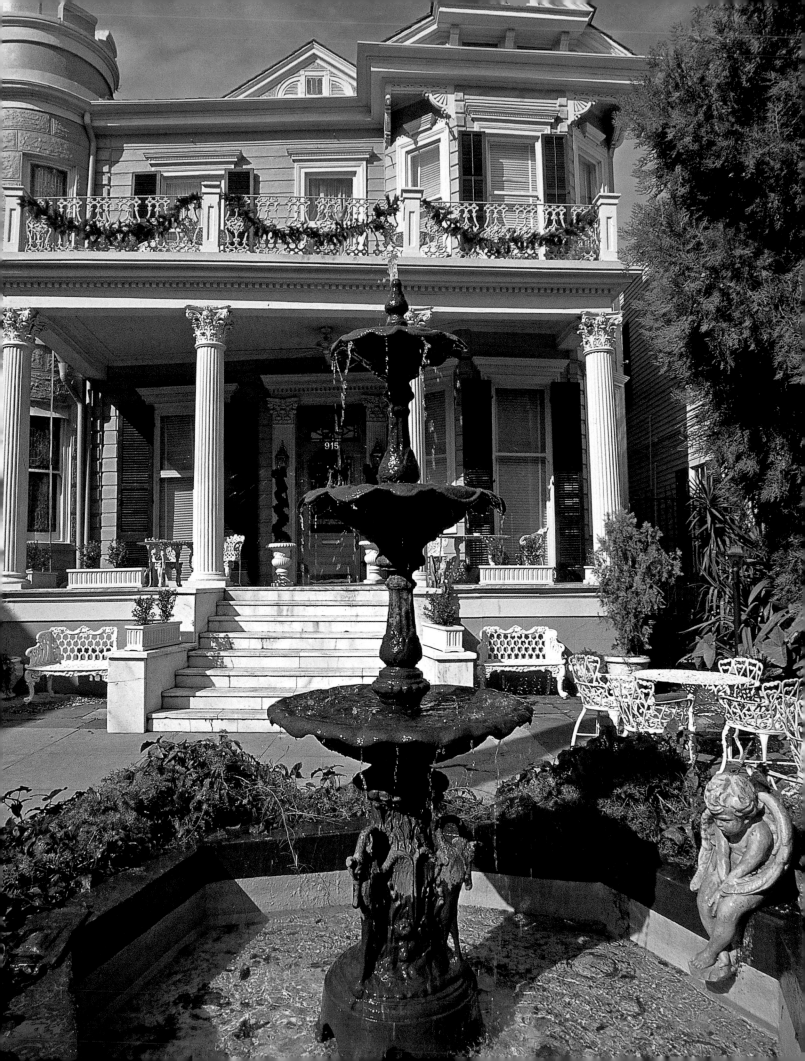

PART THREE
HISTORIC TOWN AND COUNTRY
HOUSE HUNTING GUIDE

The following is a list of some of the most beautiful and interesting historic homes in the New Orleans area. Most of the area residences listed in the National Register of Historic Places are included here. Not all are open to the public.

TOWN

The French Quarter

1850 House/Pontalba Buildings/Louisiana State Museum
Circa 1850; Styles: Greek Revival, Italianate, French Creole
523 St. Ann Street, New Orleans, LA 70116
Phone: 504-568-6968
Web site: lsm.crt.state.LA.us/1850ex.htm
Special offerings: gift shop, tours

Beauregard-Keyes House
Circa 1826; Styles: American, Creole
1113 Chartres Street, New Orleans, LA 70116
Phone: 504-523-7257
Web site: www.neworleansmuseums.com/
architecturemuseums/beauregardkeyes.html
Special offerings: tours, seasonal programs
Note: The garden at this home is restored to its original 1865 plan.

Cornstalk Hotel
Circa early 1800s; Style: Victorian
915 Royal Street, New Orleans, LA 70116
Phone: 504-523-1515 or 800-759-6112
Web site: www.cornstalkhotel.com
Special offerings: bed and breakfast
Note: The house's namesake fence was cast

ABOVE AND FACING PAGE: THE CORNSTALK HOTEL IN NEW ORLEANS' FRENCH QUARTER IS ONE OF THE MANY STRUCTURES IN THE NEIGHBORHOOD LISTED ON THE NATIONAL REGISTER OF HISTORIC PLACES. THE VICTORIAN HOME'S INTERIOR FEATURES INCLUDE HIGH-VAULTED CEILINGS, STAINED-GLASS WINDOWS, ROSETTE SCROLLS, CHERUBS, AND MEDALLIONS.

by Miltenberger Ironworks. Until 1826, this was the home of Judge Francois Xavier Martin, author of an early book on the history of Louisiana. Another corn stalk–styled fence is located at 1448 Fourth Street.

A CORNSTALK HOTEL GUEST ROOM WITH FIREPLACE, MANTEL, AND MIRROR. THE HOTEL WAS THE EARLY 1800S HOME OF FRANCOIS XAVIER MARTIN, A NATIVE OF MARSEILLES, FRANCE.

Faulkner House

Circa 1840; Style: Greek Revival
624 Pirate's Alley
New Orleans, LA 70116
Phone: 504-524-2940
Web site: www.faulknerhousebooks.net
Special offerings: bookstore, literary events
Note: This house is where William Faulkner lived when writing his first novel, *Soldiers' Pay*, in 1925. It also is part of the Labranche Buildings complex. Pirate's Alley was once called Orleans Alley.

Gallier House Museum

Circa 1857; Styles: Greek Revival, Italianate
1132 Royal Street, New Orleans, LA 70112
Phone: 504-525-5661
Special offerings: tours, "summer dress"

Girard House/Napoleon House

Circa 1797, 1814; Style: French Creole
500 Chartres Street
New Orleans, LA 70130
Phone: 504-524-9752
Web site: www.napoleonhouse.com
Special offerings: bar and restaurant
Note: New Orleans Mayor Nicholas Girod, the original owner, supposedly offered his home as a place of refuge for the exiled Napoleon Bonaparte as part of an unsuccessful plot to rescue him from the island of St. Helena. The house features casement windows and a rooftop cupola, rumored to have been built as a lookout watch for Napoleon (who never visited).

Hermann-Grima House

Circa 1831; Style: Georgian
820 St. Louis Street
New Orleans, LA 70112
Phone: 504-525-5661
Web site: www.hgghh.org
Special offerings: This home has the only functioning 1830s outdoor kitchen in the French Quarter. It offers Creole cooking classes and seasonal food exhibits.

Jean Louis Rabassa House/McDonough No. 18 School Annex

Circa 1825–1849; Style: Greek Revival
1125 St. Ann Street
New Orleans, LA 70116
Note: Famed historic New Orleans architect J. N. B. de Pouilly resided in the house at the time of his death in 1875. The home is a raised Creole cottage with a four-room plan. Its Greek Revival details were added later. This is a private residence.

Karnofsky Tailor Shop and Residence

Circa 1910
427–431 South Rampart Street
New Orleans, LA 70112
Note: The Karnofskys were a Jewish family that befriended a young Louis Armstrong (who was employed by them), loaning him money on his salary to buy his own trumpet. The area around their tailor shop and home is significant within the context of New Orleans' African-American, Jewish, Italian, and Chinese history as a rare survivor of a once-flourishing entertainment/business district that stretched for several blocks along South Rampart.

Madame John's Legacy

Circa 1789; Style: French West Indies
632 Dumaine Street
New Orleans, LA 70116
Phone: 504-568-6968
Special offerings: tours, programs.
Call for operating information.

Merieult House, Historic New Orleans Collection

Circa 1750–1799, 1825–1849;
Style: Greek Revival
533 Royal Street, New Orleans, LA 70130
Phone: 504-523-4662
Web site: www.hnoc.org
Special offerings: exhibits, gift shop, library, and lectures. The collection features changing exhibits about Creole life in the Louisiana

colony and succeeding early American periods, with an extensive art and manuscript library.

Note: The house was built in the Spanish Colonial style in 1792 for Jean Francois Merieult, a merchant-trader. Later renovations transformed the house into a Greek Revival.

New Orleans African-American Museum/ Simon Meilleur House (Treme)

Circa 1829; Styles: French Colonial, West Indies
1418 Governor Nicholls Street
New Orleans, LA 70116
Phone: 504-566-1136
Special offerings: exhibits and lectures
Note: Simon Meilleur, for whom the house was built, was keeper of the city jail. He lived in this house from 1828 to 1836.

Old Ursuline Convent

Circa 1752; Style: French Colonial
1100 Chartres Street
New Orleans, LA 70116
Phone: 504-529-3040
Special offerings: special events and exhibits

Soniat House

Circa 1829
1133 Chartres Street
New Orleans, LA 70116
Phone: 504-522-0570
Special offerings: bed and breakfast
Note: Francois Boisdore, son of a wealthy, free-black family, was the builder of this Creole townhouse for Joseph Soniat DuFossat, a sugar planter. Cast-iron galleries were added after 1865 when the porte cochere was enclosed.

Bayou St. John and Esplanade Ridge/ Kenner/Metairie

Edgar Degas House

Circa 1852; Style: Creole
2306 Esplanade Avenue
New Orleans, LA 70119
Phone: 504-821-5009 or 800-755-6730
Web site: www.degashouse.com
Special offerings: bed and breakfast, tours by appointment

Longue Vue House and Gardens

Circa 1942; Style: Classical Revival
7 Bamboo Road
New Orleans, LA 70124
Phone: (504) 488-5488
Web site: www.longuevue.com
Special offerings: a shop, museum exhibits, tours, and educational programs

Pitot House/Ducayet House

Circa 1799; Style: French Creole
1440 Moss Street, New Orleans, LA 70119
Phone: (504) 482-0312
Web site: www.pitothouse.org
Special offerings: tours and fall events

Raziano House/Mahogany Manor

Circa 1925–1949; Style: Classical Revival
913 Minor Street, Kenner, LA 70062
Note: This is a private residence.

"American" New Orleans

Aldrich-Genella House

Circa 1866, 1878 renovation;
Style: Second Empire
4801 St. Charles Avenue
New Orleans, LA 70115
Note: This is a private residence.

ANTIQUE FURNISHINGS LIKE THIS CHESS SET AND LAMP PROVIDE HISTORIC APPROPRIATENESS AT THIS SMALL HOTEL LOCATED ON ROYAL STREET.

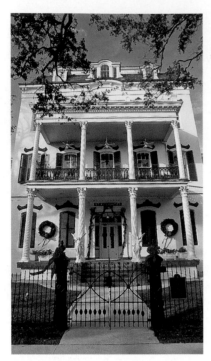

THE ITALIANATE-STYLE, THREE-STORY, RED-BRICK ST. ELIZABETH'S—A ONETIME BOARDING SCHOOL AND ORPHANAGE AT 1314 NAPOLEON AVENUE IN NEW ORLEANS' GARDEN DISTRICT—WAS BUILT FOR THE SISTERS OF CHARITY OF ST. VINCENT DE PAUL BY DESIGNER-BUILDER THOMAS MULLIGAN. DORMERED MANSARD ROOFS WERE ADDED IN THE 1880S.

Bullitt-Longenecker House

Circa 1868–1869; Style: Swiss Chalet
3627 Carondelet Street
New Orleans, LA 70115
Note: Cuthbert Bullitt commissioned German-born architect Edward Gottheil to build this center-hall, Swiss villa–style home with a wide-projecting gable ornamented with a Swiss-inspired pattern. The house was relocated from its original St. Charles Avenue location to make way for the Simon Hernsheim home, which is now the Columns Hotel. This is a private residence.

Delachaise House/Rice House

Circa 1866; Style: Italianate
3643 Camp Street, New Orleans, LA 70115
Note: This raised villa with rear brick additions was built for importer Henry Rice in 1899. From 1875 to 1973, it was a home for Protestant widows and orphans. This is a private residence.

George Washington Cable House

Circa 1874; Styles: French Creole, Raised Cottage
1313 Eighth Street, New Orleans, LA 70115
Note: Author George Washington Cable (1844–1925) had this center-hall home built for himself in 1874. Famous writers who visited the home included Mark Twain, Oscar Wilde, and Lafcadio Hearn. This is a private residence.

Grant-Black House (Grant–St. Amant House)

Circa 1887; Style: Queen Anne Revival
3932 St. Charles Avenue
New Orleans, LA 70115
Note: Charles Sully was the architect of this Queen Anne Revival home built in 1887. This is now a private residence.

Hart House/Henriques-Bond House

Circa 1873, enlarged 1890; Style: Gothic Revival, Queen Anne Revival
2108 Palmer Avenue
New Orleans, LA 70118
Note: The house was named for Toby Hart, the original owner, who was a house painter and decorator. The center-hall cottage has an unusual style, incorporating Gothic Revival with Queen Anne and Italianate features to retain its eclectic character. This is a private residence.

Huey P. Long Mansion

Circa 1920s; Styles: Mission, Spanish Colonial Revival
14 Audubon Boulevard
New Orleans, LA 70118
Note: Emile Weil designed this eclectic home named for Louisiana governor Huey P. Long, who moved here in 1932. Following his assassination, the home served as a museum in Long's memory until it was sold as a private residence in 1979.

A PAINTER CAPTURES THE BEAUTY OF THIS ST. CHARLES AVENUE GEORGIAN REVIVAL HOME. THE DE LA HOUSSAYE HOUSE IS ALSO KNOWN AS THE WEDDING CAKE HOUSE FOR ITS RESEMBLANCE TO THE WHITE-TIERED CONFECTION.

James H. Dillard House
Circa 1875–1899, 1900–1924;
Style: Greek Revival
571 Audubon Street
New Orleans, LA 70118
Note: James H. Dillard was a Tulane professor and administrator of a fund to help African-Americans. Dillard University is named for him. When the house was described in 1889, it was listed as a one-story, frame-slated dwelling with a frame-shingled, attached kitchen. At that time, it was valued at $ 2,500. This is a private residence.

Mary Louise Kennedy Genella House
Circa 1891; Style: Italianate
5022–5028 Prytania Street
New Orleans, LA 70115
Note: This is a privately owned structure.

Julia Street Row/Thirteen Buildings
Circa 1825–1849; Styles: Federal, Greek Revival
602–646 Julia Street
New Orleans, LA 70130
Note: These thirteen intact red-brick row houses have three stories with attics, side-hall floor plans, pierced entablatures with gabled ends, and chimneys.

Milton H. Latter Memorial Library/ Isaacs-Williams Mansion
Circa 1907; Styles: Italianate, Beaux Arts
5120 St. Charles Avenue
New Orleans, LA 70115
Note: This was one of the first private homes with an elevator. It also boasted a third-floor ballroom, chandeliers and mirrors from Czechoslovakia, mahogany from South America, Dutch murals, and Flemish woodwork. In 1912, Frank Williams bought the house, and when his son Harry Williams, an aviator, met silent screen star Marguerite Clark during a World War I bond-selling tour, they made it their part-time home. It is now a public library.

Louis Sincer House
Circa 1825–1849, 1850–1874, 1875–1899;
Style: Second Empire
1061 Camp Street, New Orleans, LA 70130
Note: This Second Empire–style home features a porte cochere that extends to the rear of the home. This is a private residence.

Lowe-Forman House
Circa 1897; Style: Queen Anne Revival
5301 Camp Street, New Orleans, LA 70115
Note: This is a private residence.

Newberger House
Circa 1909; Styles: Bungalow, Craftsman
1640 Palmer Avenue
New Orleans, LA 70118
Note: The Craftsman porch, columns, and Mediterranean villa–style roof were designed by architect Emile Weil in 1908 for cotton broker Sylvan Newberger. This is a private residence.

Park View Guest House
Circa 1875–1899, 1900–1924, 1925–1949;
Styles: Queen Anne, Colonial Revival
7004 St. Charles Avenue
New Orleans, LA 70118
Note: This home features a wide front porch with a decorated railing. It was first built in 1896 at a cost of $8,000. This is a private residence.

JULIA STREET TOWNHOUSES, KNOWN AS JULIA ROW, WERE BUILT IN THE AMERICAN FEDERAL STYLE. THIS STYLE WAS UNCHARACTERISTIC FOR CREOLE NEW ORLEANS BUT WAS USED IN THE AMERICAN SECTION OF NEW ORLEANS' BUSINESS DISTRICT, KNOWN AS FAUBOURG ST. MARY.

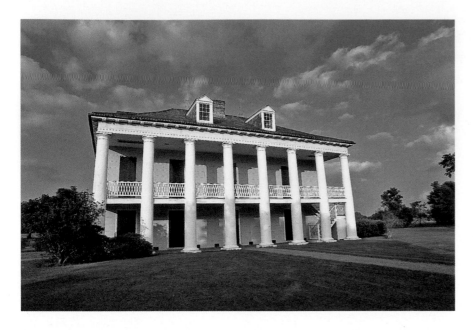

THIS 1830 MANSION WAS A HOME FOR RENÉ BEAUREGARD, SON OF CONFEDERATE GENERAL P. G. T. BEAUREGARD. KNOWN AS THE MALUS-BEAUREGARD HOUSE, IT IS LOCATED ON THE SITE OF THE BATTLE OF NEW ORLEANS, AT THE CHALMETTE BATTLEFIELD AND NATIONAL CEMETERY, WHICH IS MAINTAINED BY THE NATIONAL PARK SERVICE.

Pessou House
Circa 1875–1899; Style: Italianate
6018 Benjamin Street
New Orleans, LA 70118
Note: This raised, center-hall cottage was moved from its original State Street location prior to 1909. It was purchased in 1889 by Mrs. Carrie Pessou. This is a private residence.

Simon Hernsheim House/Columns Hotel
Circa 1883; Style: Italianate
3811 St. Charles Avenue
New Orleans, LA 70115
Phone: 504-899-9308.
Web site: www.thecolumns.com
Special offerings: bed and breakfast with Sunday jazz brunch and weekly entertainment

Sommerville-Kearney House
Circa 1875–1899; Style: Queen Anne
1401 Delachaise Street
New Orleans, LA 70115
Note: This is a private residence.

Tewell House/The Steeg House
Circa 1850–1874; Style: Italianate
1503 Valence Street
New Orleans, LA 70115
Note: This classic Italianate was once a boarding school for girls and was known as the Valence Institute. It was later sold to Moise Steeg Jr. This is a private residence.

Turpin-Kofler-Buja House/
John Turpin House
Circa 1854; Style: Greek Revival
2319 Magazine Street
New Orleans, LA 70130
Note: The former bookkeeper and partner of architect James Gallier, London-born John Turpin, built this Greek Revival–style home for his family in 1854. This is a private residence.

Walker House
Circa 1861; Style: Greek Revival
1912 St. Charles Avenue
New Orleans, LA 70130
Note: This is a private residence.

Algiers and the Westbank of New Orleans

Kerner House
Circa 1875–1899; Style: Greek Revival
1012 Monroe Street, Gretna, LA 70053
Note: This is a private residence.

Lebeuf Plantation House
Circa 1840–1850;
Styles: French Creole, Federal
101 Carmick, U.S. Naval Support Activity,
Algiers, LA 70114
Note: This is a private residence.

Magnolia Lane Plantation House

Circa 1830; Styles: Federal, Greek Revival
State Highway 541 at Nine Mile Point
Westwego, LA 70094
Note: This is a private residence.

Vic Pitre House

Built in 1925; Styles: Bungalow, Craftsman,
Colonial Revival
476 Sala Avenue, Westwego, LA 70094
Note: This is a private residence.

New Orleans Area National Register of Historic Districts

Algiers Point

Historical periods of significance:
1850–1874, 1875–1899,
1900–1924, 1925–1949.
Noted for Italianate and
Greek Revival houses.

Bywater Historic District

Historical periods of significance:
1800–1824, 1825–1849, 1850–1874,
1875–1899, 1900–1924, 1925–1949.
Noted for Bungalow/Craftsman and
Italianate houses.

Carrollton Historic District

Historical periods of significance:
1825–1849, 1850–1874, 1875–1899,
1900–1924, 1925–1949.
Noted for Bungalow/Craftsman, Italianate,
and Colonial Revival houses. In 1852, the
Carrollton Railroad ran a six-mile stretch
between New Orleans and Carrollton, a
small town later incorporated into the city.
This area experienced a lot of flooding after
Hurricane Katrina, but many houses in the
area are currently under renovation.

Central City Historic District

Historical periods of significance:
1825–1849, 1850–1874, 1875–1899,
1900–1924, 1925–1949.
Noted for Queen Anne, Italianate, and Greek
Revival houses.

Esplanade Ridge Historic District

Historical periods of significance:
1825–1849, 1850–1874, 1875–1899,
1900–1924, 1925–1949.
Noted for Greek Revival and
Renaissance houses.

Faubourg Marigny

Historical periods of significance: 1800–1824,
1825–1849, 1850–1874, 1875–1899.
Noted for Italianate and Greek Revival houses.
Bernard Marigny subdivided his plantation's
grounds to accommodate these.

Garden District

Historical periods of significance: 1825–1849,
1850–1874, 1875–1899, 1900–1924.
Noted for landscape architecture and late
Victorian and mid-nineteenth-century
Revival houses.

Gentilly Terrace Historic District

Historic periods of significance: 1900–1924,
1925–1949.
Noted for Bungalow/Craftsman and Colonial
Revival homes, which were severely damaged in
Hurricane Katrina.

Holy Cross Historic District

Historic periods of significance: 1850–1874,
1875–1899, 1900–1924, 1925–1949.
Noted for many Bungalow/Craftsman and
Italianate-style houses, which are still intact
after Hurricane Katrina.

THE LAST BATTLE OF THE
WAR OF 1812, KNOWN AS THE
BATTLE OF NEW ORLEANS, WAS
WON HERE AT THE CHALMETTE
BATTLEFIELDS IN 1815.

HOUMAS HOUSE ORIGINAL PEN-AND-INK RENDERING BY JOSEPH ARRIGO, DATED 1993. THIS RENDERING SHOWS THE ROOFTOP BELVEDERE THAT OVERLOOKS THE MISSISSIPPI RIVER.

Salmen House, also known as the Swiss Cottage or Louisiana's Chalet Suisse
Circa 1875–1899; Style: Swiss Chalet
2854 Front Street, Slidell, LA 70458
Note: This is a private residence.

River Road Vicinity

Ashland-Belle Helene
Circa 1841; Style: Classic Greek Revival
State Highway 75, between Geismar and Darrow, LA 70725
Phone: 985-675-6550
Note: James Gallier Sr. was the architect of this classic Greek Revival home that features eight giant pillars across each façade and a heavy entablature. It was named for the Kentucky home of Henry Clay, a hero of the owner, Duncan Kenner. After the Civil War, Kenner returned home only to find that Union soldiers had made themselves at home when he was away and had trashed the place. Kenner started over and re-employed loyal slaves to revive the estate. This is now a private residence, but group tours can be arranged by appointment.

Bacas House
Circa 1825–1849, 1850–1874; Style: Creole
State Route 18 (east of Evergreen Plantation), Edgard, LA 70049
Note: This is private residence.

Bay Tree
Circa 1850–1874; Style: Greek Revival
3785 State Highway 18, Vacherie, LA 70090
Note: Bay Tree was a bed and breakfast before it was purchased by the Oak Alley Plantation owners.

Bocage
Built, 1801; Styles: French Colonial, West Indies raised cottage; redesigned in 1834 to Greek Revival
State Highway 942, Darrow, LA 70725
Notes: In French, *bocage* means shady retreat. The high Empire-style entablature shades the upper gallery in this unusual jewel of formal lines and sleek columns. The house was a wedding gift to Françoise Bringier and Christophe Colomb, from the bride's father, Marius Pons Bringier.

Bon Secours Plantation/Graugnard Farms Plantation House
Circa 1750–1799, 1800–1824, 1850–1874
5825 State Highway 18, St. James, LA 70086
Note: This is a private residence.

Colomb House
Circa 1825–1849; Style: Greek Revival
Northwest of Convent on River Road
Convent, LA 70723
Note: This is a private residence.

Desire Plantation House
Circa 1835; Style: French Creole
State Highway 644, Vacherie, LA 70090
Note: This is a private residence.

Destrehan Plantation
Circa 1787; Styles: West Indies,
Greek Revival
13034 River Road, Destrehan, LA 70047
Phone: 985-764-9315 or 877-453-2095
Web site: www.DestrehanPlantation.org
Special offerings: historic demonstrations,
plantation store, festivals, tours
Note: Approximately five miles upriver from
Destrehan is the Bonnet Carré Spillway. A
devastating 1927 flood was the main reason
for this engineering feat built by the Army
Corps of Engineers. Today, the wildlife-filled
basin is reason enough to visit, and while
there you might happen upon local cane-pole
fishermen. When the spillway bays are open,
almost two million gallons of Mississippi
River water is dramatically diverted from the
nearby below-sea-level villages.

Dorvin House
Circa 1825–1849, 1850–1874
State Highway 18, northwest of
Hahnville, LA 70057
Note: This is a private residence.

Dugas House
Circa 1800–1824; Style: Colonial
State Highway 18, Edgard, LA 70049
Note: This is a private residence.

Emilie Plantation House
Circa 1875–1899; Styles: Italianate,
Greek Revival
State Highway 44, Garyville, LA 70051
Note: This is a private residence.

Evergreen Plantation
Circa 1832; Styles: Greek Revival, Federal
State Highway 18, Wallace, LA 70049
Phone: 504-201-3980
Web site: www.evergreenplantation.org
Special offerings: tours by appointment
Note: Ten massive, white columns in the Doric
order support deep galleries at this working
sugar plantation. Two matching curved
staircases lead to the second-story gallery
and centered front doors. The roof is hipped,
with matching side dormer windows and two
chimneys facing each other, fenced in by a
belvedere. On the manicured acres of grounds
are numerous outbuildings that retain the
Greek Revival style.

Godchaux-Reserve Plantation House
Circa 1825, 1850; Style: French Creole, Federal
1628 State Highway 44, Reserve, LA 70084
Note: This is a private residence.

Graugnard House
Circa 1900; Style: mixed
2292 State Highway 44, Reserve, LA 70084
Note: This is a private residence.

Hermitage/L'hermitage
Circa 1812–1814, Style; Greek Revival
State Highway 942, Darrow, LA 70725
Note: This house shares its name with Andrew
Jackson's famed Tennessee home because its
owner, Michel Doradou Bringier, wanted to
honor his beloved commander. The exterior
boasts massive Doric columns and wide galleries
surrounding the second floor. Inside a seventy-
foot ballroom flanked by two imported black-
marble fireplaces is a showcase of the estate. This
is a private residence.

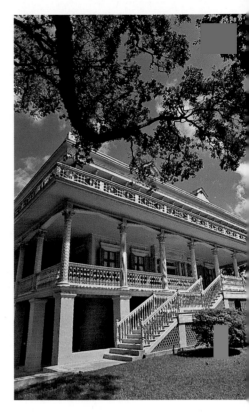

WHEN NOVELIST FRANCIS
PARKINSON KEYES WROTE
ABOUT A FICTIONAL FAMILY
THAT RESIDED HERE, SHE
COINED THE TERM "STEAMBOAT
GOTHIC" TO DESCRIBE THE
ARCHITECTURAL STYLE.
RESTORATION OF THE SAN
FRANCISCO PLANTATION HOUSE
WAS COMPLETED IN 1977.

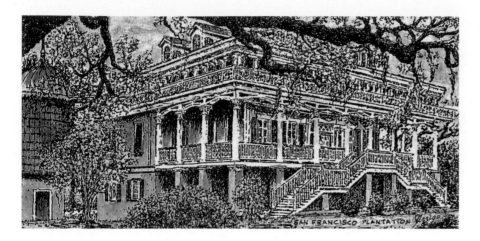

THIS PEN-AND-INK RENDERING BY JOSEPH ARRIGO SHOWS THE UNUSUAL EXTERIOR COLOR OF SAN FRANCISCO PLANTATION AND THE ADJACENT CISTERN STRUCTURE. CISTERNS, NOT WELLS, WERE THE SOURCE OF CLEAN WATER FOR THOSE WHO LIVED ANTEBELLUM HOMES.

Homeplace Plantation House/Keller Homestead

Circa 1800–1824; Style: Colonial
State Highway 18, 0.5 miles south of Hahnville, LA 70057
Note: This West Indies–style Colonial home was built in 1826 for Dr. François Robin on a Spanish land grant. This is a private residence.

Houmas House Plantation and Gardens

Circa 1829, completed 1840; Style: Greek Revival
40136 Highway 942, Darrow, LA 70725
Phone: (504) 891-9494
Web site: www.houmashouse.com
Special offerings: Latil's Landing Restaurant is in original 1700s structure.
Note: If he could prove to Union troops that he was British, then John Burnside, known as the sugar prince of Louisiana, could keep his plantation. His victory is ours today as the Houmas House Plantation (named for the Houmas Indians who once lived on the site) stands proudly with its glass-enclosed belvedere, hipped dormered roof, and columns flanking three sides.

Judge Poche Plantation House

Circa 1870; Style: Victorian Renaissance Revival
River Road, Convent, LA 70723
Note: Judge Poche was a founding member of the American Bar Association and the Louisiana Democratic Party. The house is made of solid cypress, and it features thirteen-foot ceilings and unusual front and rear dormers. This is a private residence.

Labranche Plantation, Dependency/ Barbarra Plantation

Circa early 1800s; Style: French Creole
State Highway 48, St. Rose, LA 70087
Phone: 504-468-8843
Special offerings: tours
Note: The 200-year-old garçonnière (bachelors' quarters) is the largest that is still standing on the banks of the Mississippi River. The house (which the French promptly renamed Labranche) was built for German immigrants, the Zweig family.

Laura Plantation

Circa 1820; Style: French Creole
2247 Highway 18, Vacherie, LA 70090
Phone: 225-265-7690 or 888-799-7690
Web site: www.LauraPlantation.com
Special offerings: gift shop, tours

Little Texas/Genre House

Circa 1825–1849; Style: Greek Revival
2834 State Highway 44, Paulina, LA 70763
Note: This is a private residence.

Mather House/Breaux-Mather House

Circa 1800–1824, 1825–1849
5666 State Highway 44, Convent, LA 70723
Note: This is a private residence.

Millet House

Circa 1825–1849
509 E. Jefferson Highway
Gramercy, LA 70052
Note: This is a private residence.

Montegut Plantation House
Circa 1815; Style: French Creole
1052 Highway 628, Laplace, LA 70068

Nottoway Plantation House
Circa 1859; Style: Italianate
30970 Highway 405
White Castle, LA 70788
Phone: 225-545-2730
Web site: www.nottoway.com
Special offerings: a bed and breakfast with
gift shop and restaurant
Note: Touted as the South's largest
plantation, Nottaway's grand high-ceilinged
rooms and 53,000 square feet of space do not
disappoint. This grand manse was the elusive
jewel that the producers of *Gone with the
Wind* first eyed for filming, but the owners
refused, fearing a loss of privacy. Nottaway
was built in 1857 by John Hampden
Randolph of Virginia, who chose its design
among several submitted in competitions.

Oak Alley, aka Bon Sejour
Circa 1837–1839; Style: Greek Revival
3645 Highway 18, Vacherie, LA 70090
Phone: 225-265-2151 or 866-231-6644
Web site: www.OakAlleyPlantation.com
Special offerings: bed and breakfast with a
restaurant, gift shop, and ice cream parlor
Note: The alleys of oaks that front this
mansion were used as beacons by steamboat
captains to navigate the Mississippi River.
The massive Doric columns are each
eight feet around, and the upper gallery's
balustrades are carved wood that resemble
wrought iron. "Bon Sejour," the original
nickname for the home built for Jacques
Telesphore Roman, means good visit.

Ormond Plantation House
Circa 1750–1799; 1825–1849;
Style: French Creole
State Highway 48, Destrehan, LA 70047
Phone: 985-764-8544
Web site: www.Plantation.com
Special offerings: a bed and breakfast, tours,
events, weekend farmers' market

St. Joseph Plantation
Circa 1830; Styles: French Creole,
Greek Revival
3535 I Highway 18, Vacherie, LA 70090
Phone: 225-265-4078
Web site: www.stjosephplantation.com
Special offerings: tours, store, seasonal festivals
Note: St. Joseph is a working sugar plantation
with exhibits on the cultivation of sugarcane.

TEZCUCO PEN-AND-INK
RENDERING BY JOSEPH ARRIGO.
TEZCUCO WAS A ONE-STORY,
GREEK REVIVAL PLANTATION
HOUSE LOCATED ON THE EAST
BANK OF THE MISSISSIPPI
RIVER. IT WAS DESTROYED BY
FIRE IN MAY 2002.

San Francisco Plantation
Circa 1856; Style: Steamboat Gothic
2426 River Road (Highway 44),
Garyville, LA 70051
Phone: 985-535-2341 or 888-509-1756
Web site: www.SanFranciscoPlantation.org
Special offerings: Frisco Fest Annual Spring
Garden & Craft Fest, wedding venue
Note: Though its name has nothing to do
with the city by the bay, San Francisco is
nevertheless a design marvel. The raised
Creole cottage plan evolved into its own
style, called Steamboat Gothic. After lavish
improvements were made by the owners,
they reportedly joked that they were
without a cent (*sans fruscins*) after
renovations. Somehow that French phrase
turned into San Francisco. Inside, the
mansion features imaginative decorative
treatments, including ceiling frescoes, *faux
bois* (false wood), and *faux marbre* (false
marble)—great *trompe l'oeil*.

Sorapuru House
Circa 1825–1849; Style: Federal
971 State Highway 18, Edgard, LA 70049
Note: Among its distinguishing characteristics,
this Federal-style home features eight-inch-
thick *bousillage* (mud and horsehair) walls. The
floor plan features large living rooms in the
middle flanked by bedrooms on either side,
and it does not have a center hall. This is a
private residence.

GONE BUT NOT FORGOTTEN
Tezcuco Plantation Site
Completed: 1855, destroyed by fire: 2002
3138 State Highway 44, Darrow, LA 70725

South of New Orleans, the Deep Delta

Harlem Plantation House
Circa 1840; Style: French Creole
Route 39, Point a La Hache, LA 70082
Note: This is a private residence.

Sebastopol Plantation House
Circa 1825–1849; Style: Creole
State Highway 46, St. Bernard, LA 70043
Note: Located in historic St. Bernard Parish
approximately fifteen miles downriver from
New Orleans, this one-story, wood-frame
Creole plantation house was built in the
1830s by Don Pedro Marin. The original
wraparound, cabinette-styled, columned
mantels are typical of that period.
The home sits on approximately thirty acres
of land used for sugar cultivation. The house
remained structurally intact following Katrina,
despite the fact that water entered it. This is a
private residence.

Woodland Plantation and Spirits Hall
Circa 1855; Styles: Greek Revival, Italianate
21997 Highway 23
West Pointe a La Hache, LA 70083
Phone: 504-656-9990 or 800-231-1514
Web site: www.woodlandplantation.com
Special offerings: a bed and breakfast with
restaurant, special event rental, tours

Glossary

(a list of architectural and historical terms used herein)

Banquette—The French word for seat is also the term used for the historic sidewalks of the Vieux Carré, which were between four and five feet wide, raised above the dirt street, with bricks inside a retaining wall of cypress planks.

Bousillage—A mixture of oyster shells, sand, water, and horsehair used between timber framing, then covered in plaster.

Briquette-entre-poteaux—A mud-between-posts construction method using clay and moss, which are formed into a loaf, then folded into a bar.

Colombage sur sole—A French term for houses with floors lying directly on the ground. Once builders realized that this design caused rot from excessive moisture, brick floors replaced dirt. Colombage is the cypress framing system.

Creole cottage—A single-story structure slightly elevated or at ground level. Façade features symmetrical doors and windows. House sits on front property line (no front yard). Style features a steeply pitched, side-gabled roof with a stucco brick or wood exterior. Period constructed is from 1790 to 1850.

Dixie—Originally a "dix" (French for the number ten) was a currency bill printed by the Citizens Bank with French on one side and English on the other. These were first used by keel boatmen arriving from upriver.

Eave—The lower portion of a roof that projects beyond a wall.

Entablature—The horizontal support beam (lintel) between columns and a roof.

Entasis—The gentle convex swelling of a column that makes it appear flat rather than concave.

Garçonniére—A French architectural term for an outbuilding or separate service building that was used for single men as a bachelors' quarters.

Grillage—A network of timber (mostly cypress in Louisiana) used in a foundation; also called floating foundations.

Half-timbering—Exterior decorative timber, contrasted with white walls.

Lintel—The horizontal beam at the top of two uprights to support the wall above it.

Mansard roof—A roof with two slopes, the first steeper than the second.

Parterre—A formal French-inspired divided garden that is planted on the ground and divided by paths.

Pilaster—A rectangular, attached column that engages with the structure and features a base and capital.

Porte cochere—A covered area providing shelter for passengers exiting a carriage or vehicle.

Post and lintel—A support system where a horizontal beam (the lintel) is supported by two vertical posts at either end.

Rez de Chaussée—The ground-level basement of a raised structure.

Rotunda—A circular interior space, usually surmounted by a dome.

Wattle and daub—A wall composed of woven branches filled with mud or plaster.

Selected Bibliography

American Institute of Architects, New Orleans Chapter. *A Guide to New Orleans Architecture*. New Orleans: American Institute of Architects, 1974. Library of Congress Catalog Number 74-81081.

Arrigo, Joseph. *Plantations*. Stillwater, MN: Voyageur Press, 1989.

Benfey, Christopher. *Degas in New Orleans*. Berkeley: University of California Press, 1997.

—. *Encounters in the Creole World of Kate Chopin and George Washington Cable*. Los Angeles: University of California Press, 1997.

Bruce, Curt. *Great Houses of New Orleans*. New York: Knopf, 1977.

Campanella, Richard and Marina. *New Orleans Then and Now*. Gretna, LA: Pelican Publishing Company, 1999.

Christovich, Evans, Sally Kitredge, and Roulhac Toledano. *The Esplanade Ridge* (Vol. V in New Orleans Architecture series). Gretna, LA: Pelican Publishing Company, 1977.

Fortier, Alcée. *A History of Louisiana*. New York: Manzi, Joyant & Company (successors) and Paris: Goupil & Company, 1904.

Gambino, Richard. *Vendetta: The True Story of the Largest Lynching in U.S. History*. Toronto: Guernica Editions, 2000.

Garvey, Joan B. and Mary Lou Widmer. *Beautiful Crescent: A History of New Orleans*. New Orleans: Garmer Press, 1982.

Gore, Laura Locoul. *Memories of the Old Plantation Home: A Creole Family Album*. Vacherie, LA: Zoe Company, 2000.

Hankins, Hohn Ethan and Steven Maklansky, editors. *Raised to the Trade: Creole Building Arts of New Orleans*. New Orleans: New Orleans Museum of Art, 2002.

Hirsch, Arnold R. and Joseph Logsdon, editors. *Creole New Orleans: Race and Americanization*. Baton Rouge, LA: Louisiana State University Press, 1992.

Ingersoll, Thomas N. 1991. Free Blacks in a Slave Society: New Orleans, 1718–1812. *The William and Mary Quarterly* 48 (2):173–200.

Jackson, Joy J. *Where the River Runs Deep: The Story of a Mississippi River Pilot*. Baton Rouge, LA: Louisiana State University Press, 1993.

Kostof, Sprio. *The History of Architecture*. New York: Oxford University Press, 1985.

Kukla, Jon. *A Wilderness So Immense: The Louisiana Purchase and the Destiny of America*. New York: Knopf, 2003.

Leavitt, Mel. *A Short History of New Orleans*. San Francisco: Lexicos, 1982.

Malone, Ann Patton. *Sweet Chariot: Slave Family and Household Structure in Nineteenth-Century Louisiana*. Chapel Hill: University of North Carolina Press, 1992.

Saxon, Lyle. *Fabulous New Orleans*. Gretna, LA: Pelican Publishing Company, 1988.

Saxon, Lyle, Edward Dreyer, and Robert Tallant. *Gumbo Ya-Ya: A Collection of Louisiana Folk Tales*. New York: Bonanza Books, 1984, 1945.

Sexton, Richard. *New Orleans: Elegance and Decadence*. San Francisco: Chronicle Books, 1993.

Starr, Frederick S. *Southern Comfort: The Garden District of New Orleans*. New York: Princeton Architectural Press, 2005.

Toledano, Roulhac B. *The National Trust Guide to New Orleans*. New York: John Wiley and Sons, 1996.

Vogt, Lloyd. *New Orleans Houses: A House-Watcher's Guide*. Gretna, LA: Pelican Publishing Company, 1985.

Widmer, Mary Lou. *New Orleans in the Twenties*. Gretna, LA: Pelican Publishing Company, 1993.

Williamson, Joel. *William Faulkner and Southern History*. New York: Oxford University Press, 1993.

WPA Guide to New Orleans, The. Boston: Houghton Mifflin, 1938.

Index